THE ILLUSTRATORS

Posy Simmonds

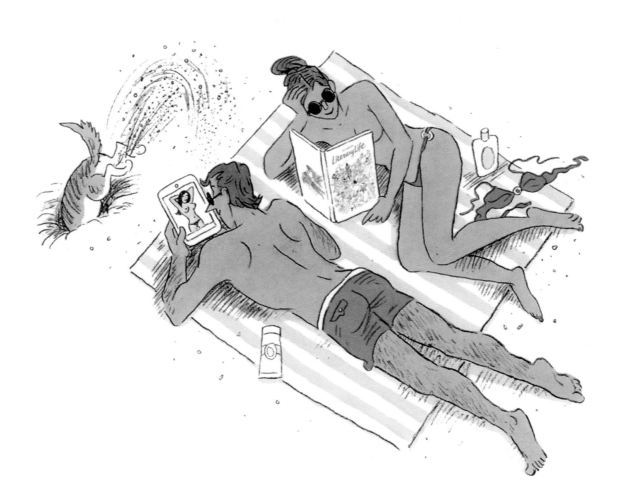

Paul Gravett

THE ILLUSTRATORS

Posy Simmonds

SERIES CONSULTANT QUENTIN BLAKE
SERIES EDITOR CLAUDIA ZEFF

WITH 115
ILLUSTRATIONS

Thames & Hudson

FRONT COVER Matilda from *Matilda, Who told such
Dreadful Lies* by Hilaire Belloc, 1991
BACK COVER Posy Simmonds, 1970, photograph © Peter Boyce

FRONTISPIECE Illustration from promotional tote
bag for the French edition of *Literary Life*, 2014
ABOVE Toile de Jouy pastiche, from the endpapers
of *Mrs Weber's Diary*, 1979
PAGE 112 Original artwork for an editorial
drawing in the *Guardian*, 1970s

PICTURE CREDITS Unless otherwise credited, all artworks
are © Posy Simmonds and are reproduced by kind permission
of Posy Simmonds. Page 27 © Peter Boyce; page 31 top right
© Beljon Archive; page 34 © Punch Ltd; page 107 David Levene/
Guardian/eyevine

First published in the United Kingdom in 2019 by
Thames & Hudson Ltd, 181A High Holborn, London WC1V 7QX

Designed by Therese Vandling

British Library Cataloguing-in-Publication Data
A catalogue record for this book is available from the
British Library

ISBN 978-0-500-02213-9

Printed and bound in China by C&C Offset Printing Co. Ltd

To find out about all our publications, please visit
www.thamesandhudson.com. There you can subscribe
to our e-newsletter, browse or download our current catalogue,
and buy any titles that are in print.

CONTENTS

Introduction

On the big screen of the Ciné Lumière cinema at the Institut Français in London, Posy Simmonds is drawing live on 25 January 2018 to accompany a discussion about how far British women have, or have not, come over the last century since women over 30 were first allowed to vote. As the cartoon takes shape, it shows the gradual ascent of man from the origins of life up to a caveman clutching a spear. But before he can reach the summit, a present-day woman has already got there, by climbing the more difficult vertical cliff, tethered to her female companion below. Simmonds explains what this depicts: 'Equal opportunity. That is what I believe in, for everybody; the opportunity to realize your potential. Which many women, particularly poorer women, haven't had.'

Posy Simmonds recognizes the opportunities, and good luck, she has enjoyed. With her talents and independence, they have enabled her to become an internationally acclaimed illustrator, writer and cartoonist. Still in her prime and continuing a career of over fifty years, Simmonds is one of Britain's most sophisticated innovators expanding the scope and subtlety of the comics medium. Based in London, she has become renowned since the late sixties, not only as a brilliant cartoonist for the national press, but also as a much-loved author and illustrator of children's books and graphic novels. Her 1981 book *True Love* can be considered the first modern British graphic novel. Until the 21st century, however, few people outside Britain knew much about Posy Simmonds, unless they discovered her weekly comics in the *Guardian* newspaper satirizing the liberal middle classes through three contrasting families, the Webers, the Wrights and the Heeps, or her wise, widely translated stories for children such as *Fred*, animated in 1996 into the Oscar-nominated short film *Famous Fred*. Her American magazine debut, one-page comics in the monthly *Harper's Magazine*, New York, ran to only fifteen examples in 1982–83 and passed largely unnoticed.

Simmonds's limited global profile was raised by her graphic novels, *Gemma Bovery* (1999), *Tamara Drewe* (2007) and *Cassandra Darke* (2018) and their numerous

ABOVE
Cartoon drawn live during a centenary conference about women's suffrage, London, 2018

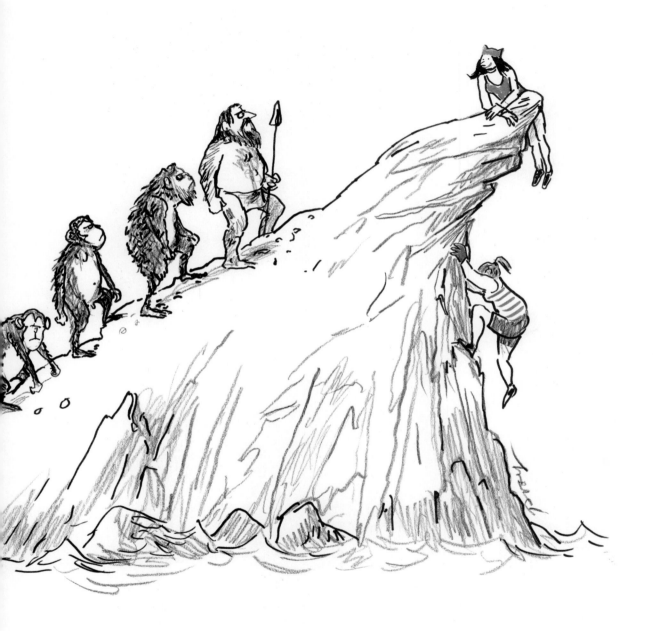

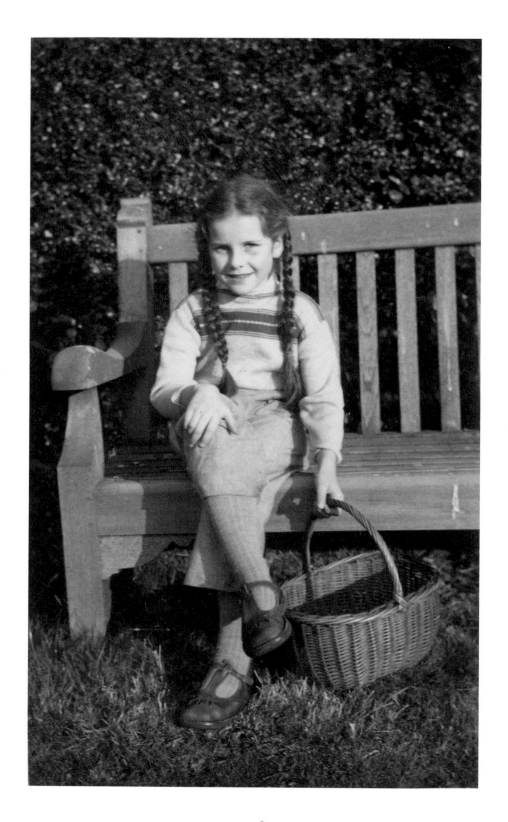

translations. More people worldwide discovered *Tamara Drewe* through Stephen Frears's film version in 2010, or *Gemma Bovery* in its French-made movie and radio adaptations. Riddled with literary and artistic allusions, repressed desires, crises and hypocrisies of conscience, the adult works of Posy Simmonds stand up as quintessentially English, but with universal appeal. As writer and broadcaster Clive James observed on his website, 'Right from the start, her ability to eavesdrop on the fashionably concerned dialogue of the time established her as more powerfully armed than almost any contemporary British novelist.' Don't be fooled by her demure manner and upper-class accent; her powers of observation across the classes are laser-sharp, her mimicry of accents and types stingingly precise. No wonder Simmonds is one of the most astute chroniclers and critics of contemporary British society.

Early years

To understand Simmonds's approach to drawing, and writing, an early memory remains a touchstone through years of interviews, conversations and correspondence with this book's author. On a summer's day in 1948, in her large Victorian home facing the family farm in Berkshire, south-east England, Rosemary Elizabeth Simmonds, aged 3 and nicknamed 'Posy', had been left to her own devices. 'There were books everywhere', she recalled, among them a set of old bound volumes of the British humorous weekly *Punch*. Looking closer, the girl became entranced by how the lines formed the faces, clothes and gestures of little figures acting their scenes. She would return to these heirlooms repeatedly to copy the drawings and make her own stories. For the perfect birthday present one year, her father gave her a ream of heavy paper, 500 big sheets at the old Imperial size Double Elephant, 678 x 1016 mm, almost A0. Growing up, she filled every sheet. The ongoing influence of *Punch* cartoons ranges from the Victorian manners satirized by George du Maurier, and 'The British Character' of the thirties, captured by 'Pont' (pen-name of Graham Laidler), to the cartoonists she admired later in the magazine, such

OPPOSITE
Posy Simmonds aged 7, about to go blackberry picking

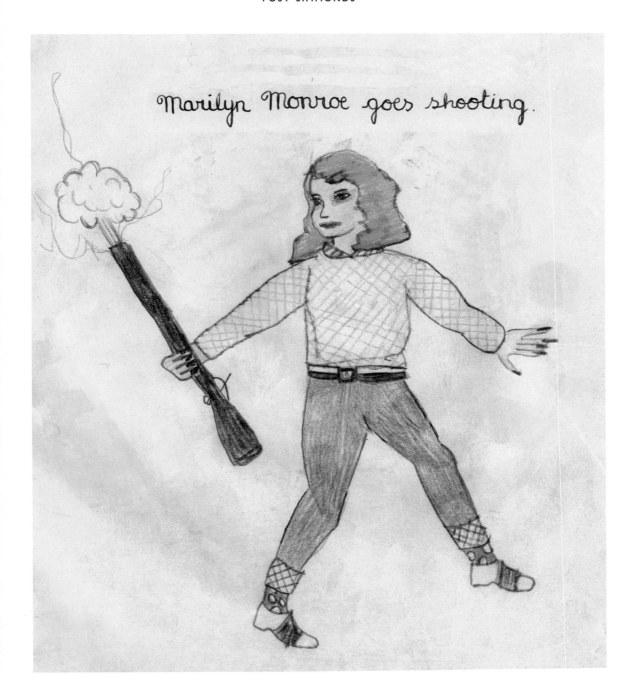

Marilyn Monroe goes shooting.

OPPOSITE

Front covers of small comic books
made between the ages of 9 and 11

ABOVE

'Marilyn Monroe goes shooting',
drawn at the age of 9

as Ronald Searle, and those whose work also appeared in *Private Eye*: 'Trog' aka Wally Fawkes, Gerald Scarfe and Willie Rushton. Her love for humorous black-and-white draughtsmanship, for that moment when black ink touches blank paper, may explain why her favourite colour has always been black. Simmonds would also come to appreciate their predecessors, the founding fathers of British satirical art, notably William Hogarth, Thomas Rowlandson and James Gillray, and channel their eighteenth-century flavour into her work, for example when invited in 2015 to make an illustration for the Foundling Museum in London based on Henry Fielding's novel *Tom Jones* (1749).

Curiosity, observation and imagination were nurtured from an early age and not so much has changed in how she works today. Simmonds and her husband, graphic designer and fellow 'visual engineer' Richard Hollis, have adjacent but separate studios in the basement of their Georgian townhouse in Clerkenwell, London, which they moved into in 1991. Simmonds has her private space to think and create on paper, where she still casts her characters by sketching their faces, clothes, props and body language, and practising and transcribing what they say and how they say it. An uncanny mimic since childhood, she enjoys testing their lines out loud, finding their accent, perhaps by precisely reproducing someone's speech, overheard that day on the bus – 'two of the best routes are the 19 and 38'. For inspiration, she can gaze at the framed cartoons on the walls: 'Above the fireplace are prints of Rowlandson's Vauxhall and William Nicholson's woodcut portrait of Whistler. Near the window is a cartoon by David Low, which has brilliant caricatures of Churchill, Hitler, Mussolini and others, drawn with the sparest of brush lines.'

Growing up on a farm, eventually the middle child of five, gave Posy no-nonsense exposure to the reality of rural life. This experience informs her work, which often contrasts town and country, and shatters the (sub)urban fantasy of escaping it all and somehow being purified by being closer to nature. This thwarted dream crops up regularly, from the Wrights' 'gem of a XVIth century cottage' or the Webers' harried holidays in 'Tresoddit', Cornwall, to Gemma Bovery's Normandy nightmare. Seeing how

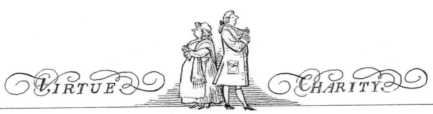

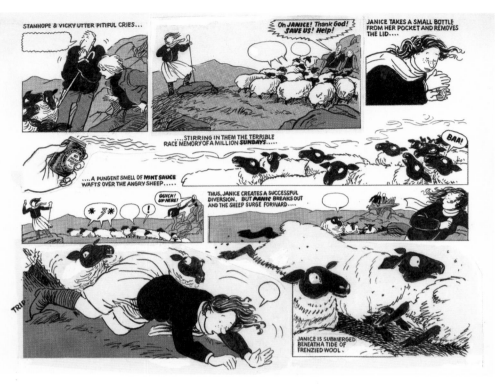

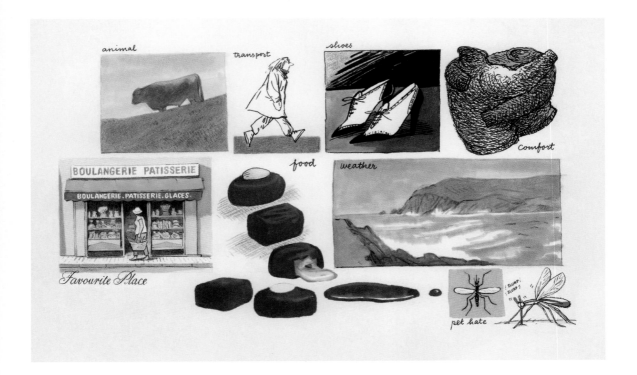

livestock are reared and can sometimes behave also gave Simmonds an unsentimental knowledge of animals. She has never forgotten how a stockman on a neighbouring farm was trampled to death by a Dexter cow protecting its calf. 'They're small cattle but little buggers. I quite like animals getting their own back on humans.' There are echoes of this in Simmonds's *True Love*, in which Janice's fantasies of revenge backfire when her open jar of mint sauce panics a flock of sheep and she winds up 'submerged beneath a tide of frenzied wool'. Far deadlier are the rampaging Belted Galloway cattle in *Tamara Drewe*. A menagerie appears throughout Simmonds's work, from family pets like the Webers' guinea pig Keith or the rock-star moggie Fred, to wildlife and mating rituals in general as metaphors for human behaviour and sexuality. It is revealing that in her self-portrait made up of her favourite things for *What Are You Like?*, an exhibition by the House of Illustration, London, in 2008 at Dulwich Picture Gallery and based on the Victorian parlour game, her favourite animal is a bull.

Childhood comics

An equally fundamental influence on Posy's childhood creativity and eventual career choice was reading and making comics. All sorts came into the house or into her hands via her elder brothers and classmates and she read everything. She began with nursery favourites *Playbox*, the *Rainbow* and *Chick's Own*, their panels usually accompanied by expository typeset text beneath, which voracious Posy read. In the early fifties, she and her brothers were the right age to graduate to the *Beano*, the *Dandy* and the *Topper*, home to the zany freshness of cartoonists such as Davey Law, Leo Baxendale and Ken Reid; to the new, smarter, worthier photogravure 'strip cartoon weeklies', *Eagle*, *Girl*, *Robin* and *Swift*; and to the girls' story papers *School Friend* and *Girls' Crystal*, which converted into comics in 1950. Her fondness for *School Friend*'s plucky, boarding-school sleuths 'The Silent Three' helped prepare her to leave home herself after she had only just turned eleven, and would prompt her to revive the trio in 1977 as adult wives, mothers, friends and still detectives in her initial *Guardian* strips.

For the postwar period, her parents were unusually relaxed about their children reading comics. By the early fifties, they could not have been unaware of the alarmist press, radio and television exposés blaming imports and British reprints of American 'horror comics' for encouraging illiteracy and delinquency. A campaign by women's groups, teachers, the Church of England and the British Communist Party pressured Parliament into banning them in 1955 through the Children And Young Persons (Harmful Publications) Act. Although this resulted in virtually no prosecutions, it forced their publishers to self-censor or to close. So when Posy joined one of her brothers at Herries School in Cookham Dean in 1951, American comic books were specially prized. Among the pupils she befriended were children of US Air Force officers, who were happy to pass on their well-read copies purchased at the airbase in Ruislip. Simmonds recalls squirrelling away *Superman*, *Sad Sack*, *Nancy* and the occasional chilling horror title, as well as American colour newspaper supplements of the 'Sunday Funnies' starring Blondie, Krazy Kat and Dick Tracy, to

16

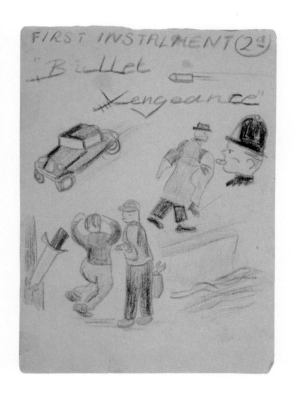

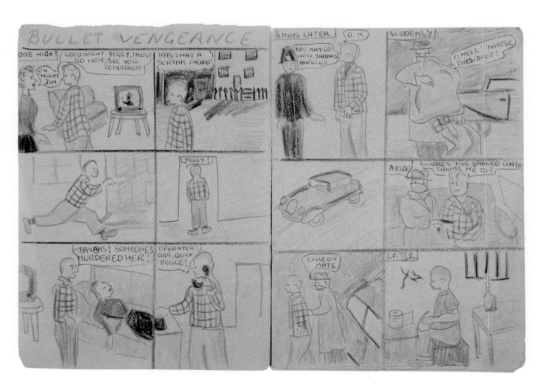

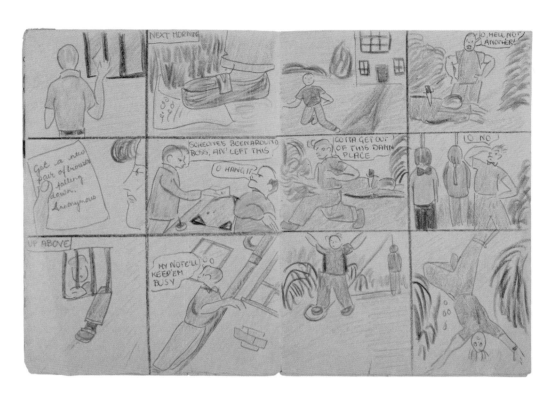

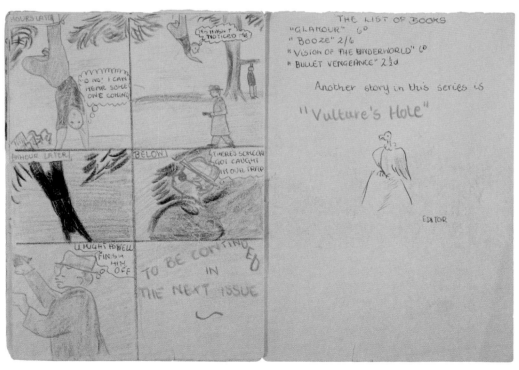

spend a perfect morning reading in her particular part of the capacious attic. 'I liked how you can voyage around the page. You can have a little tour in them.' Her Proustian memory is falling asleep with an open comic book covering her face, breathing in its distinctive bouquet. These inky dreams and detective radio dramas such as *Paul Temple* and *Dick Barton – Special Agent* spurred her to make her earliest comics around the age of 8, entitled 'Bullet Vengeance' and 'Red Dagger'. For all their naiveté, the talent and potential are already there.

Posy's education at the venerable girls-only Queen Anne's School, Caversham, extended beyond the curriculum. As a boarder allowed home only three Sundays per term, she developed great self-reliance and determination and formed lasting friendships with three pupils. Academically, she shone in English, French, Latin and Art. She continued to read independently, hoovering up the school library and a wide variety of periodicals. In her early teens she became glamourized by the stereotyped, chaste thrills of British romance comics, and crafted a precocious but innocent version of women's magazines entitled 'Herself', which was confiscated at school for being in bad taste. Posy was not entirely taken in by their promises of marital and domestic bliss. 'From an early age, I never dreamed of weddings, and at the end of fairy tales, when it said "And they lived happily ever after", I knew it ended because nothing else happened to them.'

When her French teacher, a stylish woman from France, gave the class Flaubert's *Madame Bovary* (1857) to read, its tragic heroine's ennui chimed with Simmonds's growing suspicions about marriage.

It was the 1950s and although my school encouraged you to go to university, there was the assumption that on marriage you would give it up. So I had an idea that there was this very short space of time after you left school to realize yourself and your own ambitions, and then the curtain came down and you became worthily domestic.

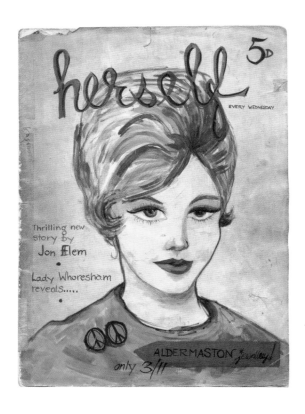

LEFT AND BELOW
Cover and double-page spread
from 'Herself', a women's magazine
made by Simmonds at the age of 14

OPPOSITE
'Why Marriage?' for the *Guardian*,
2002

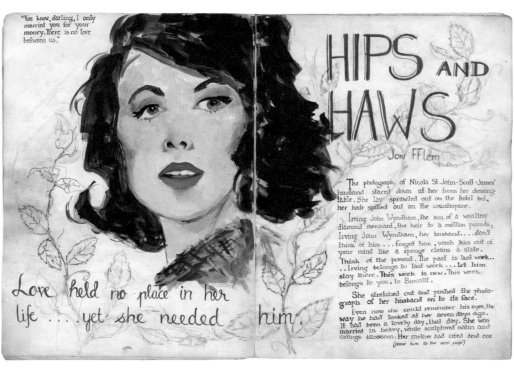

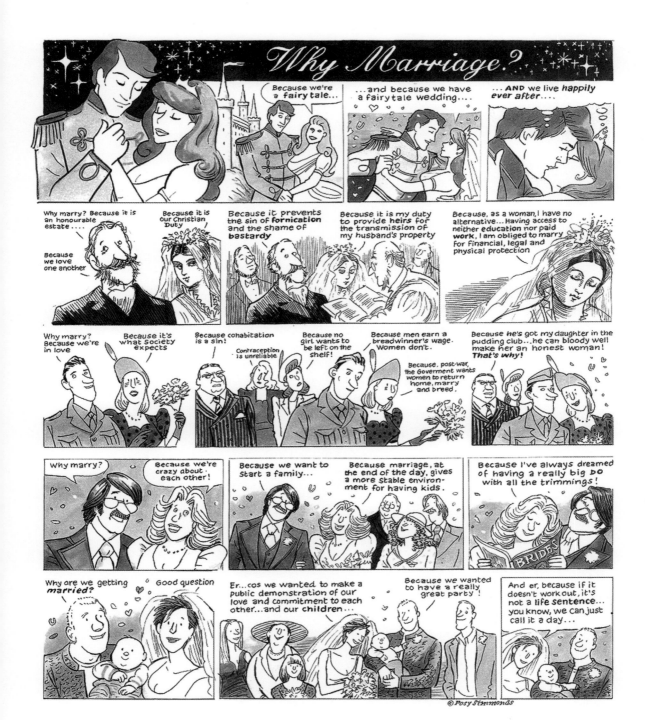

Simmonds set her sights on getting into art school to become a painter. She chose the 'Extra Art' class and left Caversham in 1962 with just her Art A-Level, passing it in only one year.

Paris and London calling

When Simmonds turned 17, her parents arranged for her to go abroad, for the first time and unaccompanied, to stay with families in Paris and join international students on a year's course at the Sorbonne and some additional art classes. For Simmonds, Paris was not a 'finishing school', but an opportunity to get boarding school out of her system. Not that she smoked, drank or misbehaved, but new friends, experiences and freedoms, her first city to explore, meant that she was not just learning about French language, culture and politics in class, but soaking them up every day, and writing and drawing about them in her sketchbooks. She read all the set texts and more, but by the summer term of 1963, 'Life had got so interesting culturally and socially, I sort of outgrew the classes' and she never took the final exams. On her return her parents forgave her and overcame their shock at her transformation from sensible tweed into the black-only chic of Juliette Gréco, and a lifelong Francophile.

Home in Cookham Dean, she was itching to get into art school in London. Intent on becoming a painter, from October 1963 she spent six months doing life drawing and painting at the Heatherley School of Fine Art in Pimlico. As she later recalled, 'there wasn't really a course, just two big studios with models…and tutors' but it filled time constructively before starting at Central School of Arts and Crafts (now Central Saint Martins) in autumn 1964. Unfortunately, she had applied too late to study painting, but while collecting her portfolio, she met the head of the 'Pre-Diploma' department, who recommended she resubmit for the foundation course instead. She was accepted and spent the year experimenting, trying etching and lithography, and responding to influences from painter-lecturers such as pop artist Derek Boshier.

OPPOSITE
Pen-and-ink sketch of apartments in Paris drawn when Simmonds was a student in the city, 1962

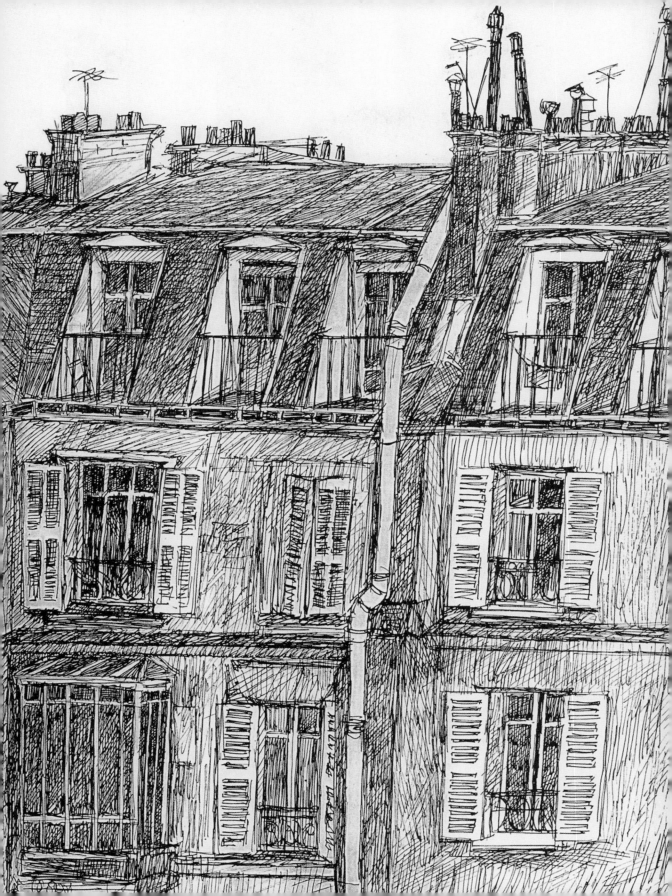

By the end, however, she resolved that she was not going to be a painter. 'Commercial art had a pejorative ring to it. But I always liked writing with drawing and so that was what I wanted to do.' Although Central had no illustration department, she could include it as part of her chosen degree in graphic design. The variety of projects enabled her to explore different styles, including a cookery book, in which she illustrated a recipe for 'a brace of partridges on a bed of watercress', adding a touch of Saul Steinberg and André François. However, she struggled with the manual practicalities of mechanical typesetting: being ambidextrous was usually more of a hindrance than a help. Simmonds had been naturally left-handed, though from an early age she had been encouraged to write and draw with her right hand.

Pen-and-ink figure drawn in life class at Heatherley School of Fine Art, London, 1964

Untitled student project from second year of the graphic design course at Central School of Art and Design (formerly Central School of Arts and Crafts), 1966

my name is bond, basildon bond, spawn of two mecca ravy dance addicts, it all comes so easy in the dark hours, they even had a knitting machine and fashioned strange, rustic happenings upon it. i said often, don't

terrorize your children, for they will do likewise and sometimes messily. pat their little grey gaberdine heads and be old and wise. they grow more assets than you do leaves. it's a marvellous form of invest ment. when the time came to leave, i hit paternoster

AARGH beneath the belt and van ished with that etruscan hulk.

hey nonny nonny no, with a ho

AH, FEELING HER WELL KNIT LIMBS BENEATH THE BOUCLE TWEED AND REIN DEER HAIR, GAZE INTO THE WEEDED PONDS OF HER EYES. JUG JUG PU WEE.

cock a snook would you

and it came to pass, at forty years of age, that i married a knitting machine in a mecca dance hall, and forgot to rave for three hundred years.

Nonetheless, what she learnt about typography enabled
her to hand-letter accurately to size and length and in her
invented font 'Anal Retentive'. And these college days, 'when
you could rent a flat, unheated, no phone, no fridge, gas
meters, cheaply in London's West End by sharing with four
or five others', would bring authenticity to Jocasta Wright
in her *Guardian* strips, the fine art student Simmonds
never was.

ABOVE

'Partridges on a bed of watercress',
illustration for a cookery book
project at Central School of Art
and Design, 1967

Getting published

Simmonds's first published illustrations graced the dustjacket of *The Grass Beneath the Wire*, a novel by John Pollock published while she was still at Central in 1966. Her title lettering, done by hand by rubbing down each letter from sheets of Letraset dry-transfer type, was, as she describes it, 'v. wonky' but 'the publisher Anthony Blond wrote me a cheque for £25 and I used it to open a bank account'. This design and other work at her degree show in 1968 was spotted by newspaper cartoonist Mel Calman, who left his card and offered to help. She rang him and followed his advice on whom to approach, how much to show and to always book an appointment to meet in person. Work proved thin at first, but Simmonds was determined to support herself and got by, doing odd jobs such as being a cleaner. Living near *The Times* helped when they called her in on 23 October 1968 to illustrate a Women's Page feature on home conversion and redecoration. 'Working conditions were absolute panic and my pen was all wobbly with nerves!', she recalls, but she delivered five spot cartoons by the 5 p.m. deadline and was in print the next day. Being local and reliable meant the paper would hire her again.

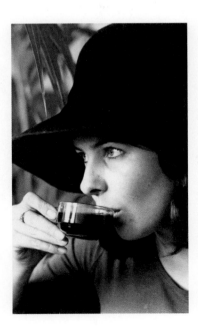

ABOVE

One of five cartoons about house conversion from Simmonds's first commission for *The Times*, 1968

RIGHT

Posy Simmonds, aged 24, sipping an espresso coffee, photographed by Peter Boyce, 1970

private-spirited men and women, whose only concern with the war is whether it will curtail their intake of gin. Michael, whose love and cheques both bounce, drifts to Soho, where he is betrayed by a loyal citizen who wants to make sure that her club is not shut down by the police.

After a court-martial, Richmond finds himself protected from the enemy by the confines of the glasshouse and although he is sometimes paraded to listen, in stony silence, to the triumphs of the army in which he serves, his main occupation is pulling up by the roots the grass beneath the wire.

Jacket designed by Posy Simmonds

Anthony Blond Ltd.,
56 Doughty Street,
London, W.C.1

ABOVE

Simmonds's first published illustration: the dustjacket for the novel *The Grass Beneath the Wire* by John Pollock, 1966

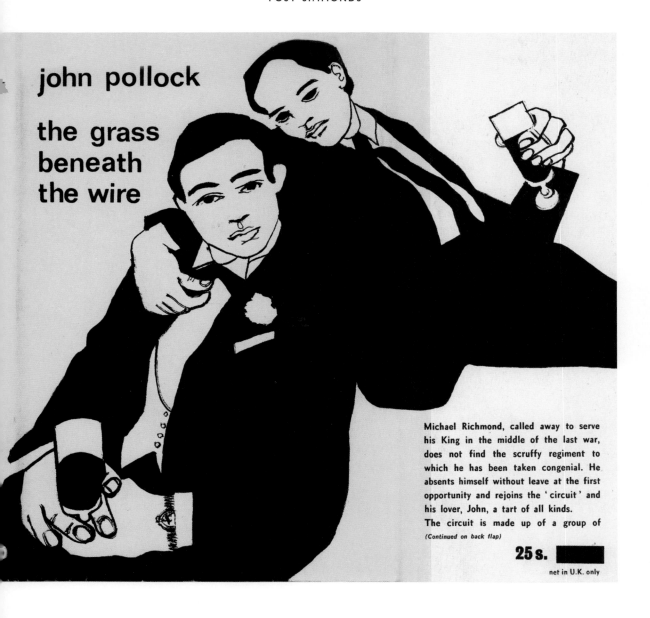

john pollock

the grass
beneath
the wire

Michael Richmond, called away to serve
his King in the middle of the last war,
does not find the scruffy regiment to
which he has been taken congenial. He
absents himself without leave at the first
opportunity and rejoins the 'circuit' and
his lover, John, a tart of all kinds.
The circuit is made up of a group of
(Continued on back flap)

25 s.

net in U.K. only

Gradually, other clients commissioned her, and her style
under pressure took on some of Calman's fleetness and
economy of line. Simmonds's first book was published in 1969
by a small publisher as a humorous novelty, with a red stamp
on the cover warning, 'Keep out of reach of children'. For *The
Posy Simmonds Bear Book* she devised mildly saucy cartoons,
in a rounded, slightly twee and childlike style, about a girl's
toys come to life, and the lascivious males – the titular teddy

bear, as well as a penguin, rabbit and golliwog – who make suggestive advances to one little female doll.

A copy reached Larry Lamb, the new editor at the *Sun*, recently sold to Rupert Murdoch and being revamped as a tabloid. Simmonds was contacted and contracted; as deputy editor Bernard Shrimsley later recalled: 'It's all in the mind, said the delicious Miss Posy Simmonds when she brought Bear & Co. along to the *Sun*. Unblinking, she looked at us through spectacles the size of old Rolls-Royce head-lamps, until we took her word for it.' 'Bear by Posy' was announced as a regular feature in the first new-look *Sun* on 17 November 1969. Wisely, Simmonds widened the locale of 'Bear' from the nursery to the real world, dropped the racist golliwog, sidelined the penguin, and made the object of the initially unwanted attentions from Bear, and sometimes Rabbit with his large carrot, into a wide-eyed, full-bodied, mini-skirted and all-but-mute Dolly bird. These cartoons, in a sweet, faux-naive style in pen-and-ink line, were part of a tabloid that now sold on sex and sexism and on its first anniversary in 1970 introduced the Page 3 topless pin-up.

ABOVE
Original artwork for two 'Bear' cartoons published in the *Sun*, early 1970s

Simmonds found devising racy innuendos six days a
week demanding and realizes that today 'Bear' appears
dated and politically incorrect. Nevertheless, it is more than
a footnote in her *oeuvre*, consisting of over 1,500 cartoons
by 1975, by which time two paperback collections of them
had been published. Also, despite her apparent reserve,
schoolyard banter had introduced her at an early age to the
joys of a double entendre or a 'blue' joke, another staple of
her later strips.

'Bear' was only part of Simmonds's output in the early
1970s: 'other drawings, where I could put more into it of
myself, were much more important'. She was also freelancing
for *Reader's Digest*, *Woman's Own*, the UK edition of
Cosmopolitan, launched in 1972, and the same year for the
Guardian, which at the time was based in the *Sunday Times*
building in Gray's Inn Road, also conveniently near where
she lived. 'As an illustrator, you always have a choice: of
decorating, or decorating and interpreting. Or if you disagreed
with the text, presenting a counter argument.' Her illustrated
editorial commentaries would start a long association with
a newspaper far more in tune with her political and feminist

ABOVE
Title illustration for the column 'Life's Like That' in *Reader's Digest*, 1970s

OPPOSITE, ABOVE
'Black is White' cartoon for the *Guardian*, 1974

OPPOSITE, BELOW
Editorial illustrations for the *Guardian*, mid-1970s

principles, as in her 1974 cartoon about South Africa entitled 'Black is White'. Soon she was illustrating on the *Guardian*'s Women's Page, alongside columnist Jill Tweedie. Simmonds and Tweedie had met through Mel Calman in 1968, and shortly after Tweedie proved a life-saver by letting a 'very broke' Simmonds survive most of her first year out of college as her lodger.

Elsewhere on the newsstands, *Punch*, whose back volumes had been so alluring to Simmonds since her childhood, remained an almost entirely male bastion, until it was challenged in 1972. As a result, for one week only, their 29 March issue was, in the words of former Labour Cabinet Minister and guest editor Barbara Castle MP, 'written, edited, cartooned and produced – except, of course, in areas such as printing where they are barred – entirely by women'. Ahead of publication, regular editor William Davis arranged some publicity and photo opportunities by inviting Castle to join women contributors, including Simmonds, outside the *Punch* offices in a staged protest about women's exclusion from the weekly. Placards called for 'Judies of the World Unite!', in reference to Mr Punch's wife. Simmonds drew four clever barbs for the 'Women Take Over' special, but the following week men were back in charge. Her first drawings for *Punch* would prove to be her last. More positively, through her *Guardian* work she was commissioned to provide thirty-seven cartoons for a 'Penguin Special', *Women's Rights: A Practical Guide*. Her sharp wit, including a parody of *Snow White* drawn in her 'Bear' style, spears the inequalities and injustices British women were suffering in 1974.

That year would also bring Simmonds's marriage to Richard Hollis, an innovative graphic designer. Richard had

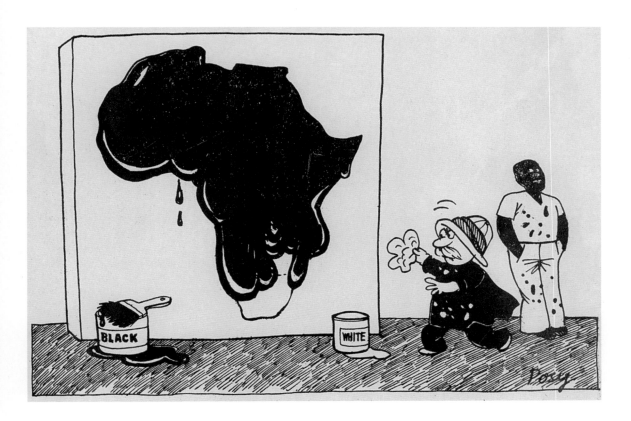

HER MASTER'S VOICE

first met Simmonds in 1968 during her last year at Central, where he was a year tutor, although he did not teach her. He was separated from his wife, with whom he had two small boys. Richard turned 40 in 1974 and Simmonds was eleven years younger than him. She would help Richard raise his two sons and they would not have children of their own. Her new life as a stepmother and party to the aftermath of a divorce informed and deepened her cartooning. In the 1970s, marital breakdown became increasingly common, with the divorce rate doubling over the decade, and would provide a topical context for several of her later characters. Similarly, relationships involving differences in ages would recur in her comics. For example, the Wrights grow concerned when their daughter Jocasta in her late teens brings home Stefan Torte, a mature Cambridge mathematics professor, while the repeated dalliances with younger women by Stanhope Wright himself, and by Nick Hardiman in *Tamara Drewe*, are no secret to their wives.

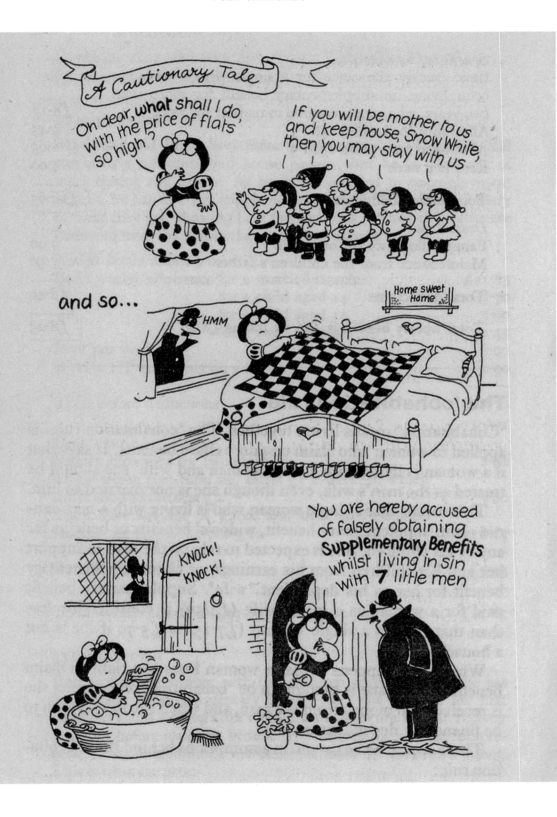

Weekly on the *Guardian*'s Women's Page

Since it started in 1957, the *Guardian*'s Women's Page had attracted a loyal readership, and not solely female, for its agenda to report and improve women's lives. In 1969, features editor Peter Preston hired John Kent to supply large weekly strips starring his blonde bombshell Varoomshka, named after German model and actress Verushka. Described by Kent as 'A Miss Everyone who, unlike most people, manages to retain a sense of incredulity at all she encounters', his Candide-like blonde would ask naive-yet-direct questions of the politicians behind that week's chicaneries, while she modelled the latest revealing fashions. Varoomshka was one

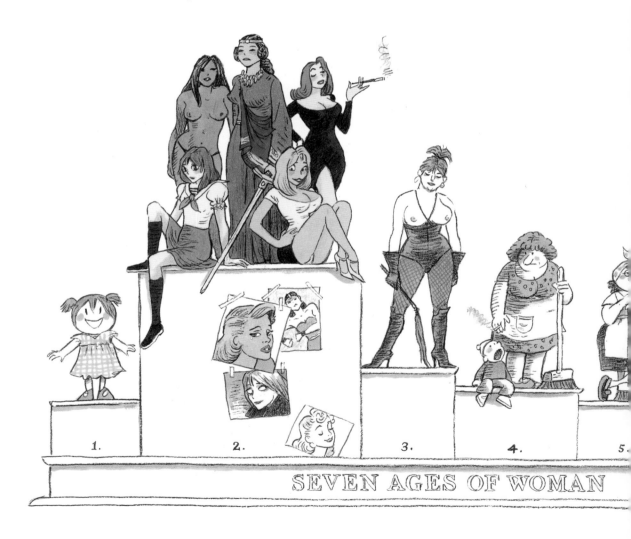

SEVEN AGES OF WOMAN

1. 2. 3. 4. 5.

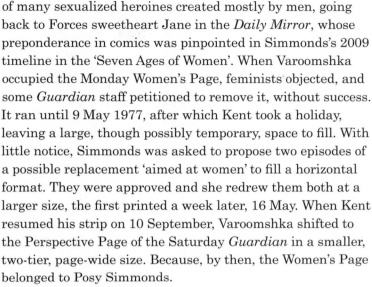

of many sexualized heroines created mostly by men, going
back to Forces sweetheart Jane in the *Daily Mirror*, whose
preponderance in comics was pinpointed in Simmonds's 2009
timeline in the 'Seven Ages of Women'. When Varoomshka
occupied the Monday Women's Page, feminists objected, and
some *Guardian* staff petitioned to remove it, without success.
It ran until 9 May 1977, after which Kent took a holiday,
leaving a large, though possibly temporary, space to fill. With
little notice, Simmonds was asked to propose two episodes of
a possible replacement 'aimed at women' to fill a horizontal
format. They were approved and she redrew them both at a
larger size, the first printed a week later, 16 May. When Kent
resumed his strip on 10 September, Varoomshka shifted to
the Perspective Page of the Saturday *Guardian* in a smaller,
two-tier, page-wide size. Because, by then, the Women's Page
belonged to Posy Simmonds.

By rotating Varoomshka's portrait space ninety degrees,
Simmonds was granted an unusually expansive and
flexible landscape format, six columns wide, in which to
tell her stories. Challenged to invent her first regular strip,
unrelated to any editorial, book or advertising brief, she
took a known template and updated it, a solution she had
used before and would use again. In 'The Silent Three of
St Botolph's' Simmonds introduces three contrasting 'Old
Girls', who twenty years ago left their public school, much
like Caversham. Ever since, they have remained friends and
become wives and mothers with kids: Trish or Mrs Stanhope
Wright (second wife to the divorced Stanhope); Wendy or Mrs
George Weber, and Jo or Mrs Edmund Heep. Now in their
thirties, the trio secretly continue to right wrongs, garbed in
'the enveloping gabardine' of their hooded robes, as 'The Silent
Three'. Simmonds changed the names of the girls and their
school from their original adventures in *School Friend* from
1950 to 1963, but trusted some *Guardian* readers would recall
them fondly. Without fanfare or explanation, the strip's tone
struck quite a contrast not only to Varoomshka, but to the
mostly serious reporting on the Women's Page.

In her second week, Simmonds began a topical farce
in three parts, 'The Case of the Sandringham Tartlets', in
which her chummy, plummy heroines thwart the threat
to The Queen's Silver Jubilee Garden Party from some

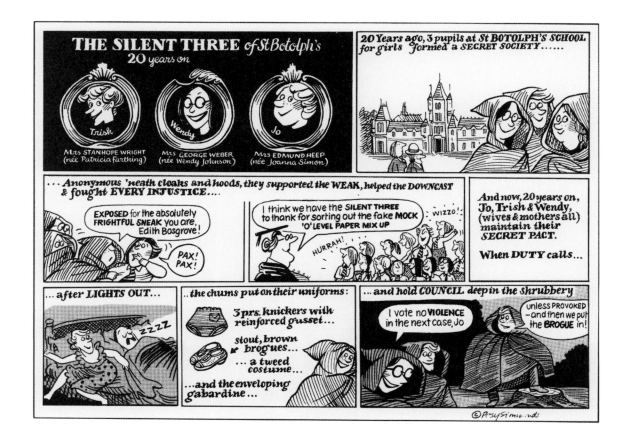

exploding pastries, which wind up in an 'Auto-Destructive Art Retrospective' at London's trendy Institute of Contemporary Arts. In a revealing sixth strip, Simmonds compares the hopes of Trish, Wendy and Jo in 1957 leaving school, armed with St Botolph's motto – 'Do what you can/Being what you are/Shine like a glowworm/If you cannot be a star' – with how their lives progress a decade and two decades later. For example, in 1967 Wendy has married young and after their second child is also a girl, husband George wants a boy. Then in 1977, all the 'I wants' are voiced by the husbands, not their wives: Stanhope's dream is, 'I want to finish Jocasta (daughter from his first wife) at Neuchatel…but can't afford it'; Jo's husband Edmund has no greater ambition than 'to be area sales manager'; and now that Wendy and George have finally had their first boy, Benji, after five girls, Wendy comments, 'It's what he wanted'. Any aspirations these women had to 'shine' have been completely sidelined by what their men wanted.

ABOVE

The first installment of 'The Silent Three of St Botolph's: 20 years on', *Guardian,* 16 May 1977

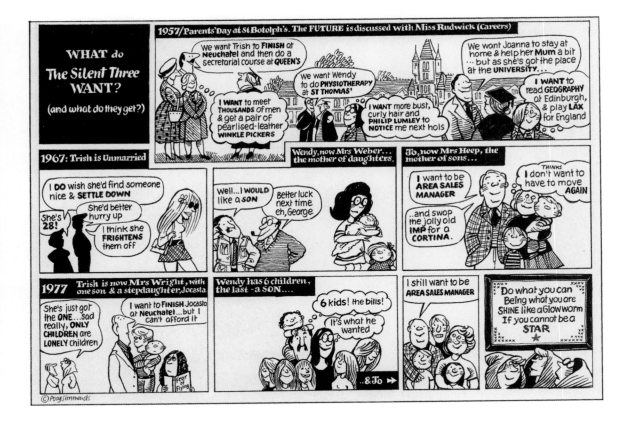

ABOVE
'What do The Silent Three
Want? (and what do they get?)',
Guardian, 20 June 1977

Posy Simmonds would try a few more continued stories during her strip's first six months but was told that reader response was lukewarm. However, she was fortunate: 'The *Guardian* gave you time to develop it. No other paper would have let you make a mistake.' So she quietly retired 'The Silent Three' from their mystery solving and focused more on complete, stand-alone episodes to reveal the women, their families and their milieus. A turning point came when she took the Webers on holiday to the fictional fishing village of Tresoddit in Cornwall, drawing on the Cornish retreat where she and Richard would escape from London. 'The more I drew them, the more I began to know them — earnest, well-meaning woolly liberals. The middle classes offer good mileage in their trying to be correct and nice to whales, and so on.' *Guardian* readers were also getting to know them, and recognizing, if not themselves, then others they knew.

In the studio

Although she was familiar with comics, Simmonds now had to deliver an ongoing strip, learning on the job one week at a time. Early on, she added an unnecessary 'THINKS' sign to alert readers to a thought balloon, and elsewhere inserted labels saying 'HURT' or 'GUILT' to signpost a character's feelings. She quickly realized she could best convey emotions by drawing recognizable types with expressive facial and body language, and allowing their appearance, clothes, the slightest telling detail, to reveal their personality. Her approach to caricature avoids exaggeration and cruelty, and belongs to the understated tradition of 'Anton' (pen name of Antonia Yeoman), Osbert Lancaster, Ronald Searle and other British cartoonists she admires.

Facing Simmonds above her drawing board hangs a large mirror, a Christmas present from Richard, in which she can pose as her own model for expressions, hands and so on. As can also be seen in her drawing of her studio, she uses a magnifying lens for close-up details. Familiar with the perils of newsprint reproduction, she makes her lines deliberately bold, bringing an economy and clarity to her drawing for practical reasons. 'My artwork was enormous, A3 but slightly squarer. I always worked large for the paper because the printing was so bad. You had to use a fat pen, and fine lines tended not to reproduce at all.' At the time, the *Guardian*'s printing was so smudgy the ink came off onto your fingers. In time, the printing would improve, enabling her to draw richer details and textures and write more copy in compact fonts, confident that they would print crisply.

Simmonds developed a step-by-step system to invent her characters and storylines for her *Guardian* strips, which she would refine further for her graphic novels.

RIGHT
'The Work Room', drawing for the
Guardian, 22 December 2007

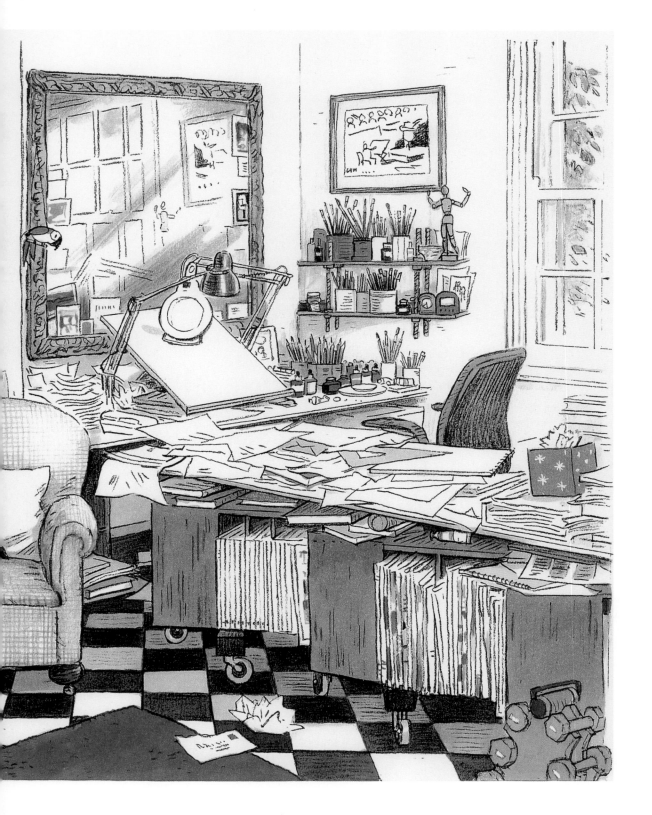

I'd start in a notebook without really having written anything. For me it's the most important stage, where I make all the major decisions about characters, the typical things they might say. I try a little bit of dialogue often with them. I draw her – or him. I choose their shoes. I choose their nose, or rub out their nose and put in another. I think: Do they drive? What kind of car do they have? Where do they live? It's a kind of casting couch. Also, you are doing costumes, make-up and props. And bit by bit the character begins to get a life of their own and you begin to recognize them.

From these ideas in her notebooks, Simmonds prepares the script and layout of each strip.

The writing is always difficult – that and the actual designing of the page require peace and quiet. Once it's written, I make a little layout and rough it out in pencil on A3 paper. Particularly the writing where the balloons are, because then you know whether the drawing has got to be small or you can do a close-up. Then I draw it frame by frame and hand-letter the balloons.

In the *Guardian*, Simmonds would frequently opt for three horizontal rows, totalling around ten to twelve panels, because

it had a kind of rhythm. I had an establishing shot and the title was often important because it gave the flavour. I usually had a long shot to show where you were and who was there. By the end of the first row, there was a hook or a twist, which was the problem that set it up. By the end of the second row it was the next bit, which had to twist it again. Then, bottom left usually was a springboard to the end. Often I didn't want a punchline. There would be a word said and then you'd just walk away from it.

42

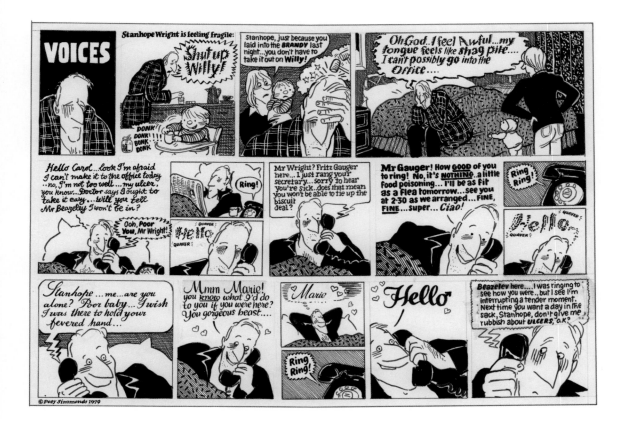

ABOVE

Stanhope Wright in 'Voices',
original artwork for the *Guardian*,
10 December 1979

Her avoidance of overemphasis means Simmonds letters
her texts by hand in upper and lower case, sans serif for
dialogue, serif for captions, instead of all in capitals as is
customary in comics, and she usually prefers italic or bold
to add stress or volume. But when histrionics or 'hamming'
are called for, this mistress of calligraphy can design fonts to
express every emotion. She punctuates with few exclamation
marks, and favours ellipses to make her characters' speech
and thoughts naturally pause, and to give her captions a
measured flow.

Mrs Weber's Diary

At the end of June 1978, Simmonds dropped 'of St Botolph's' from the series logo. Fifteen months later, she abandoned 'The Silent Three' title altogether and continued giving most strips their own title each week. More by luck than planning, 'The Silent Three' concept gave her three different wives and mothers and their families to develop into individuals, who also typified the English white urban middle classes of the period. With dots for eyes looking through big oval spectacles, Wendy Weber is a resourceful ex-nurse and children's book writer, while husband George is a senior lecturer in Liberal Studies at a polytechnic and a structuralist intellectual. Both espouse fair-minded liberal/ left-wing principles, which they vacillate about and do not always live up to. Compared to the Webers', the Wrights' marriage is more affluent but less solid. Trish puts up with the multiple infidelities of urbane Stanhope with his noble aquiline nose, creative director of an advertising agency. Trish also struggles with her conscience, for example over having a second home or employing a cleaning lady. Of the trio, Jo Heep is the least developed, with the spotlight more on husband Edmund, whom Simmonds portrays as a Mr Micawber-like paterfamilias in the whisky trade with a penchant for booze and colourful phrases.

To contest parental attitudes and received ideas and broaden her perspectives on society, Simmonds spotlighted the families' rebellious teenagers: the Heeps' two punk sons, and especially the daughters, Belinda Weber, 16 and unsure about her future, and Jocasta Wright, 19, studying art in Cambridge. Whenever necessary to serve her story, Simmonds could bring in Stanhope's first wife, George's fellow teachers, the Webers' relatives, 'Old Botolphian' Pauline Woodcock, or a one-off character, for example to comment on sexism at work. Through some 420 episodes from May 1977 to June 1987, Simmonds's principal players barely changed. 'I decided to keep them the same age. Benji stayed 3 and Belinda got engaged.' In fact, Belinda altered the most by rejecting her parents' values, training in upmarket catering rather than studying, and becoming a 'yuppie'. Simmonds was reflecting the changing

ABOVE
An unpublished drawing of Wendy, George and Benji Weber, 1985

44

political climate: 'Instead of woolly liberals, it became very carnivorous. It was as though money had taken over. The characters felt at odds with the very Thatcherite boom.' In a grand finale she brought all the cast together from across the political divide for Belinda's posh marriage to Alistair, of the 'deep-dyed Conservative' Razer-Dorke family. It appeared on 1 June 1987, ten days before Margaret Thatcher's third election victory. The final word goes to Benji, the next generation, breaking the fourth wall to say 'Bye Bye'.

From her *Guardian* strips, Simmonds conceived her first 64-page collection as one year's entries from *Mrs Weber's Diary*, published by Jonathan Cape in 1979. She hand-lettered new diary jottings by Wendy to introduce each comic, and reformatted and partially redrew twenty-two episodes to work across spreads. It sold well, so Cape asked her for a follow-up and in 1981 she produced *True Love*.

BELOW

'The world turned upside-down' for the *Guardian*, 11 May 1987

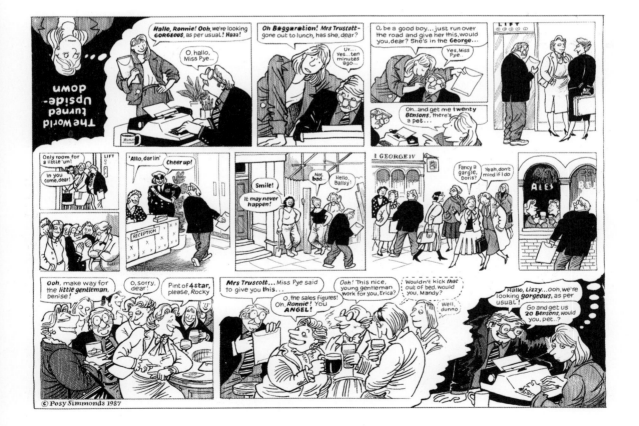

I wanted to see what I would be like at telling a whole book in pictures. I chopped it up into chapters, because I wanted to deal with different kinds of love: married love, young love, impossible love. Being used to doing instalments, I did one chapter at a time. It was like writing a little play, divided into acts.

She began with the setting of her *Guardian* cast and introduced Janice Brady, a pretty but plain young secretary at Beazeley & Buffin Advertising, who is convinced by a passing wink and an unpremeditated Christmas gift of a jar of Stilton cheese that her boss, married Lothario Stanhope Wright, fancies her. Simmonds visualizes Janice's reveries by transforming her into an impossibly beautiful, pouting, massive-haired stereotype from British romance comics. The genre's bold, fashion-conscious style was pioneered around 1957 by Spanish illustrators Jordi Longarón and José María Miralles and was followed by many others. Simmonds

BELOW

Covers from two weekly comics: *Serenade* drawn by Angel Badia Camps, 11 January 1963, and *Marilyn* drawn by Enrique Badia Romero, 15 December 1962

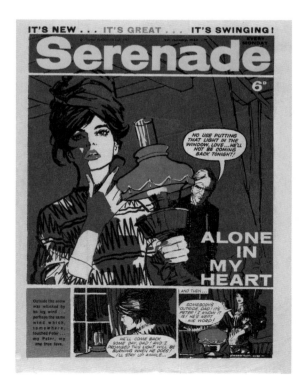

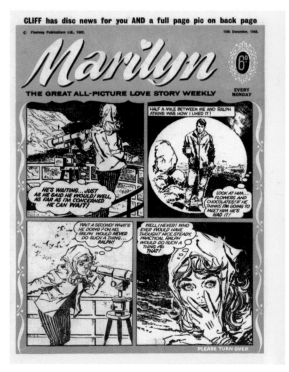

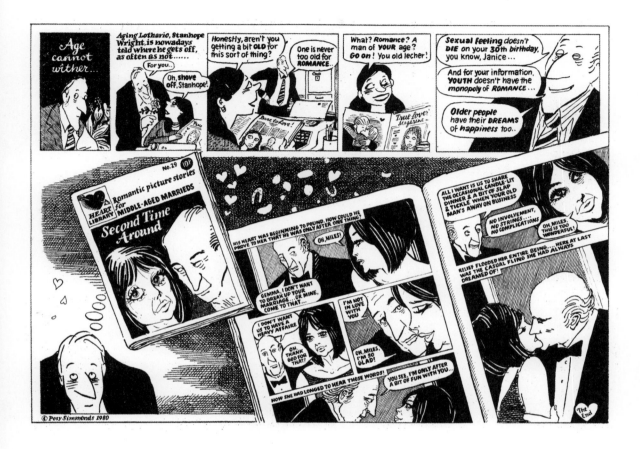

mimics to perfection the love comics' exaggerated glamour, overblown prose, capital-letter font and signature addition of a second colour in lipstick pink. Many of the book's fourteen chapters reprise or partly reprint previous *Guardian* strips, sometimes recast to feature Janice. The result, the 48-page *True Love*, romps through a central theme in Simmonds's *oeuvre*, the promises and problems of romantic love. Three further compilations of 96 pages each followed from Cape, who gathered all five in 2012 as *Mrs Weber's Omnibus*, an inaccurate title as over one hundred of the *Guardian* episodes have yet to be reprinted.

ABOVE

'Age cannot wither…' for the *Guardian*, 25 February 1980

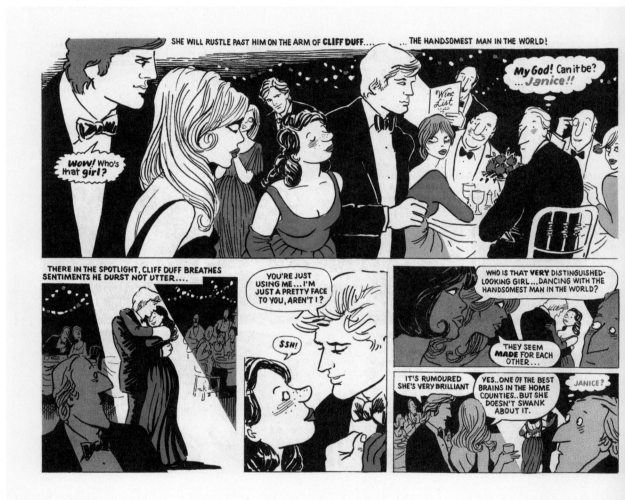

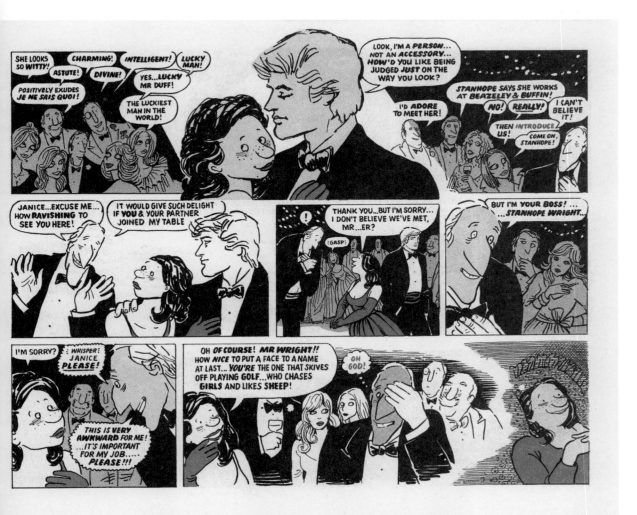

As the Dusk gathers on *Christmas Day*, a Little Match Girl stands in the snow.....

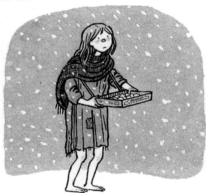

The soft flakes fall from the sky like *goose feathers*......

Behind *double-glazing*, coloured lights *blink*...and *blink* in supplication......

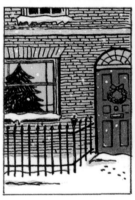

...The Little Match Girl presses her tiny nose up against the cold glass....

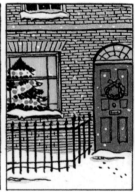

...and peers inside...

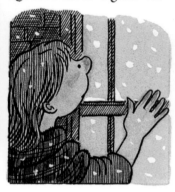

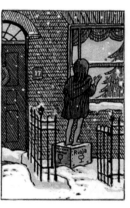

...And her warm heart *melts* with *sorrow* for the *poor*, costive folk within.....

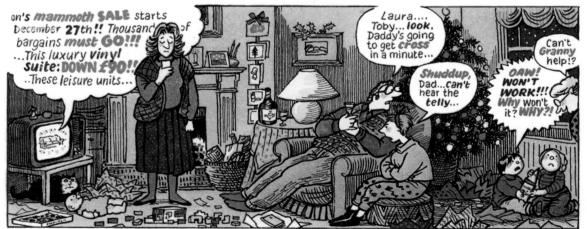

Children's books and other commissions

Because Simmonds worked for the mostly monochrome British daily press, she seldom had the opportunity to use colour. Exceptions came via illustration commissions, for example a present-day retelling of Hans Christian Andersen's *The Little Match Girl* for the *Observer* Magazine's Christmas issue in 1984 or the occasional book cover, such as *A Concise History of the Sex Manual* (1986). For younger readers Simmonds had used a lighter, sketchier touch with a hint of Quentin Blake to draw the colour covers and black-and-white interiors for collections of Kit Wright's humorous poetry, starting with *Rabbiting On* (1978) and *Hot Dog and Other Poems* (1981). In 1987, Simmonds transferred

OPPOSITE
First page of an updated retelling of 'The Little Match Girl' for the *Observer* magazine, 23 December 1984

RIGHT
Cover of *A Concise History of the Sex Manual* by Alan Rusbridger, 1986

RABBITING ON

The moon's a big white football,
The sun's a pound of butter.
The earth is going round the twist
And I'm a little nutter!

-- Just to give you a taste of this
highly original and entertaining
collection of thoughts, observations,
chunterings, musings and ditties by
Kit Wright, Britain's funniest and
tallest poet.

U.K. 50p*
Australia $1.50*
New Zealand $1.50*
Canada $1.50
*recommended price

0 00 671342 4

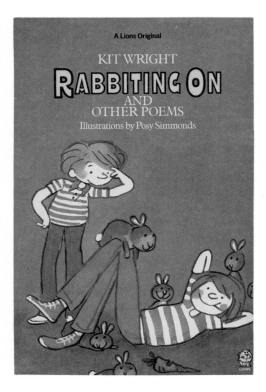

A Lions Original

KIT WRIGHT

RABBITING ON
AND OTHER POEMS

Illustrations by Posy Simmonds

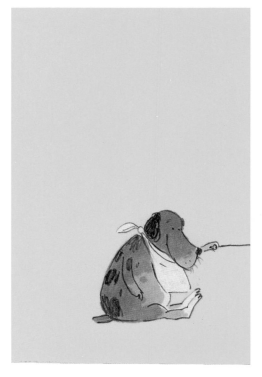

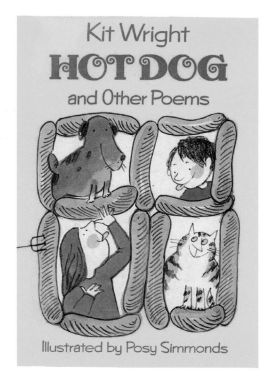

Kit Wright
HOT DOG
and Other Poems

Illustrated by Posy Simmonds

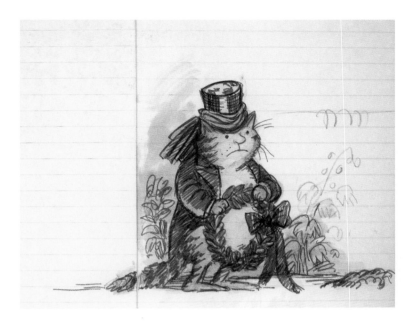

OPPOSITE
Front and back covers of poetry
collections by Kit Wright from 1978
and 1981

ABOVE
Early sketch for *Fred*, Simmonds's
first children's book, 1987

all her expertise from the *Guardian* into glorious full colour in her first children's picture book, *Fred*. The genre traditionally entailed large illustrations with modest, fine-tuned typeset narration. Simmonds ignored such conventions and worked as usual in panels and balloons on her longest tale since *True Love*, one that would deal with death and help children understand it.

As so often, life and her sketchbook planted the seed to her tale: 'A great friend had died, very young, of skin cancer. I went to the funeral and afterwards I drew cats crying and as undertakers.' Further drawings gestated into the tale of Fred, an ordinary lazy tomcat to his young owners, until one evening they discover that he leads a double life. He is a nocturnal Elvis-like rock star, so adored that upon his death thousands of his feline fans flock to his funeral in the back garden. To plan how this tale would unfold, Simmonds next prepared a dummy with 'the right number of pages (32), the complete text and the illustrations roughly drawn in pencil. The text is the most important thing at this stage, showing if the idea works as a story.' From the little brother and sister to crowds of cats, each one with personality, from humdrum interiors to nights-on-the-tiles, *Fred* proved her deft handling of colour across the spectrum.

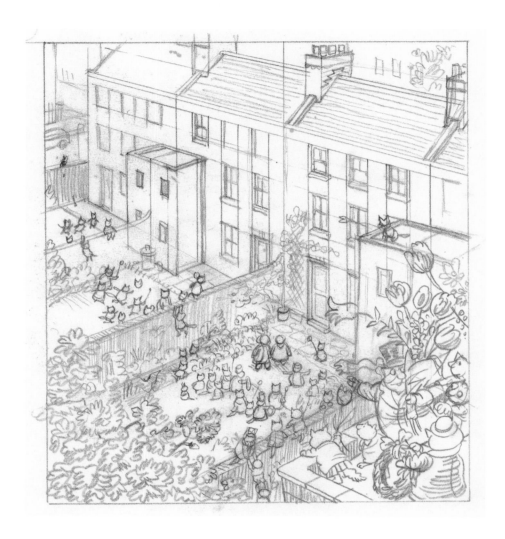

ABOVE AND OPPOSITE
Pencil rough and finished colour
illustration for *Fred*, 1987

*Sometimes, particularly if it's a simple image, I'll
draw it in light pencil, put some colour on – ink
usually, but often with crayon, felt tip and gouache
mixed in – then I'd toughen up the line with a
sharp black crayon. Berol Karisma were the gold
dust pencils, giving a dense, creamy texture; they
sharpened beautifully, in a huge range of colours.
I treasure my little stubs.*

Berol stopped making them in January 2005, so she
was lucky to inherit later an almost unused set from a
friend's mother.

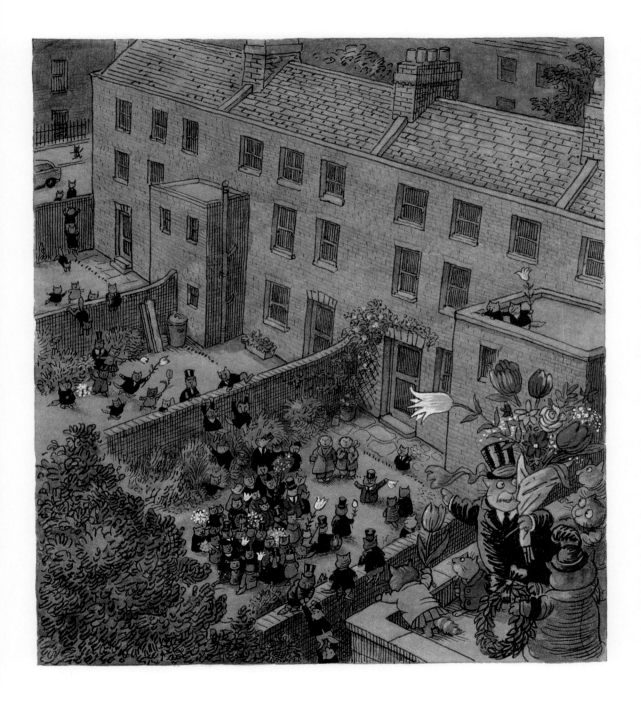

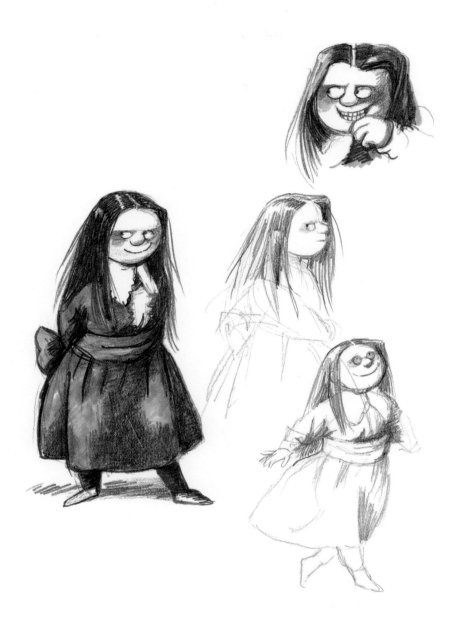

OPPOSITE

Dummy layout in pencil and finished colour version of a spread from *Lulu and the Flying Babies*, 1988

ABOVE

Character studies for *Matilda, Who told such Dreadful Lies*, by Hilaire Belloc, 1991

Her second children's book, *Lulu and the Flying Babies* (1988), came from her noticing harassed parents trying to shush their offspring in art galleries and used the full width of the double page to produce an enchanting tour-de-force, prompting a sequel, *Lulu and the Chocolate Wedding* (1990).

In 1991, Simmonds's admiration for Charles Addams, the American master of macabre comedy, influenced her illustrations for *Matilda, Who told such Dreadful Lies*, based on Hilaire Belloc's poem 'Matilda, Who told Lies, and was Burned to Death'.

> *For more complicated drawings with a lot of detail, I rough it out first in pencil, and then, on a light box, use the rough as a guide for the finished drawing. Sometimes I colour a photocopy of the finished drawing in case the first attempt at colour goes wrong.*

OPPOSITE
Original artwork for 'Jim, Who
ran away from his Nurse and was
eaten by a Lion', from *Cautionary
Tales* by Hilaire Belloc, 1997

ABOVE
Original artwork for *Lavender*,
2003

Simmonds returned to Belloc's *Cautionary Tales* in 1997
to produce black-and-white spot illustrations and some
colour whole pages for a Folio Society edition, preparing
each colour on a separate layer. With a limited palette for
The Folio Book of Humorous Verse in 2002, she chose three
contrasting flat colours, because 'I wanted them to be quite
strong, the blue and terracotta used more sparingly than the
yellow'. Her return to anthropomorphic fables for children
led to the endearing rabbit *Lavender* (2003), sensitively
drawn entirely in coloured pencils, and the exploited *Baker
Cat* (2004), whose sad subsistence is transformed by his
alliance with hordes of mice. Making these children's picture
books was where Simmonds honed her skills at originating
lengthier cohesive stories and prepared her for the graphic
novels to come. To this day, her works for children deal
with meaningful themes, like sibling rivalry or countering
prejudice, demonstrating her conviction that 'They have got
to have something true in them, however much is wrapped
up in fantasy.'

Changing times

The new year of 1988 unveiled Simmonds's surprise two-year commission, one page per month in colour for the *Spectator*. Her move to this right-wing weekly magazine marked quite a shift from the centre-left *Guardian*. She wanted to try writing 'against the grain' by reflecting Tory values and characteristics of *Spectator* readers in her 'Man/Woman/Person of the Month'. Subverting from within, she reintroduced her grouchy author J. D. Crouch from the *Guardian* and invented wealthy broker Miles Upmaster. Each profile opened with a revealing portrait alongside a two-column text biography inlaid with a few panels. Her drawings were vibrant and exquisite, adjusting style and colouring to send up her targets, whether for a Gainsborough pastiche of a landed art dealer or a minimalist look for a trendy designer. There was a detectable sharpening of the knives in Simmonds's satire, as her cartooning dissected the selfishness and inequalities of Margaret Thatcher's Britain and produced a bank of new characters to develop in the future.

On 12 February 1988, a redesigned *Guardian* was unveiled and its printer's ink improved, sharpening the reproduction. That April, Simmonds returned briefly to the Tuesday Women's Page with 'Seven Bounden Duties', her details more meticulous, her satirical critiques more stinging than ever. She also continued as a seasonal fixture in the paper for Christmas, a perennially potent theme for her social commentary, and a chance to catch up with some of her cast. For example, in 1987 she cleverly modernized Dickens's 'A Christmas Carol' through mock-Victorian engravings and lyrics that parody 'While shepherds wash their flocks...'. Edmund Heep plays 'The Ghost of Christmastide', who fails to prick the conscience of a Scrooge-like stockbroker. The next year, Simmonds dropped in on Alistair and Belinda, now 'director of Canapé Express (bespoke party food)', as they debate the venue, menu and conversation if they spend Christmas at the Webers or the Razer-Dorkes, or simply stay in their luxury duplex. Simmonds spent 1989 delivering one strip a month of an untitled series for the Women's Page, often concentrating

POSY SIMMONDS

a lot of ideas into them. It is as if her newfound freedom to create longer stories for children was spurring her to pack more narrative into this one-off strip format, which seemed increasingly to constrain her narrative ambitions.

One outlet was her chance in 1991 to script, present and partly design a forty-minute television documentary in the BBC series 'Byline'. *Tresoddit for Easter* was inspired by the Webers' fictional holiday destination, made real by filming in and around Polzeath and incorporating animation that combined dozens of specially made colour drawings with photographic backgrounds. The programme looked at the impact of tourists, of 'emmets' or new non-Cornish residents, and second-homers like Simmonds and her husband themselves, who locals saw as spoiling the very fishing villages and countryside they want to enjoy.

Her comeback to weekly strips on 7 March 1992 launched another untitled series for the Saturday *Guardian* in a shallower but wider format. Running into 1993 and covering

BELOW

'Six Bounden Duties.... No. 1: Conservation'. Originally published as 'Seven Bounden Duties' in the *Guardian*, 19 April 1988; one was dropped in the book version

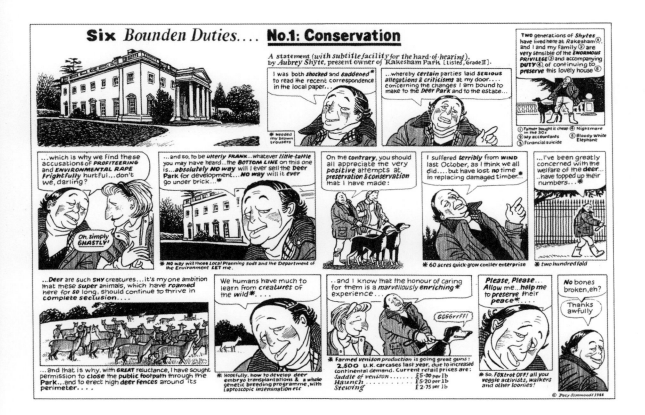

61

May

A GENTLEMAN RIDI...
dated 1988

Oil on canvas 39 × 49...
Private collection

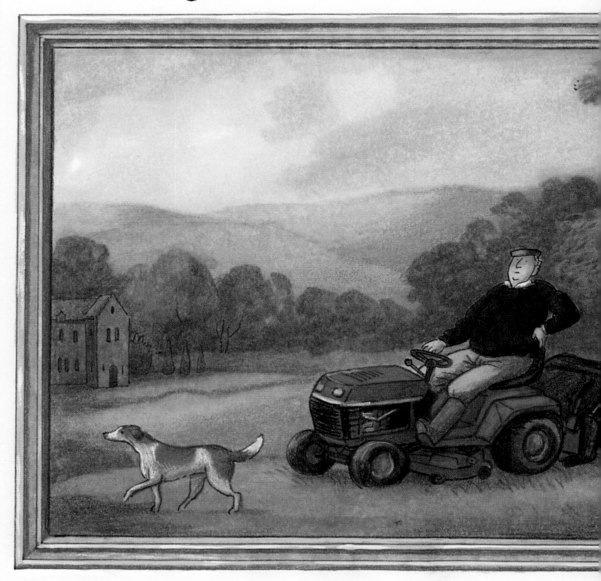

A HOUND

(4·4 cm)

The sitter is identified as MR ROBIN CHUTNEY-DARKE, a dealer in C18th & C19th English painting, with premises, (BREAM & DARKE), in St James's.

He is posed against his property near SWINDON, where he lives with his wife and family.

ROBIN CHUTNEY-DARKE was educated at ETON and AGNEWS, (he began there as a porter), and set up his own business with CHARLES BREAM c.1972. He is the subject of several other paintings, notably:

● GENTLEMAN SITTING AT THE WINDOW TABLE AT CECCONI's.
● GENTLEMAN FLYING SWISSAIR AS PASSENGER WITH PAINTING.
● GENTLEMAN RACING AT CHISWICK. (CHUTNEY-DARKE races a two-year old Mercedes on the flat between SWINDON, his town house in S.W.3 & his office.)

His cri de coeur, when buying, is: "Chr∗st, this sale is cr∗p!" ... and, when selling: "In two years time, this'll look a STEAL!".....and in the saleroom, the surfaces of the many, heavily restored paintings cause him endless grief... "LINOLEUM would be an improvement....."

LEFT
'May: A Gentleman Riding with a Hound', Simmonds's homage to Thomas Gainsborough, *Spectator*, 7 May 1988

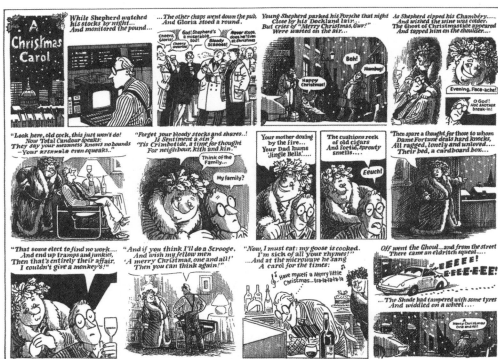

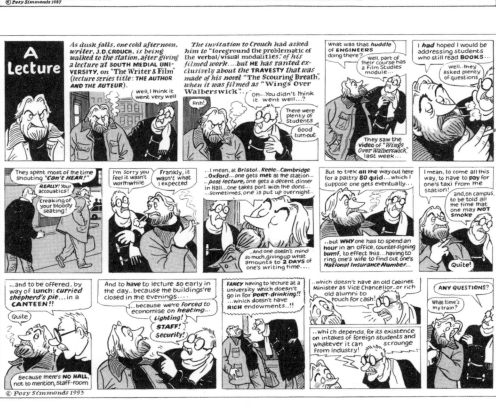

the last year of the UK's early nineties recession, these highlighted the 'Hard Times' and hypocrisies of a different cast, led by soon-to-be-redundant reinsurance broker Miles Upmaster, first seen in the *Spectator*, and his posh wife, Vanessa, and by novelist J. D. Crouch and his no-nonsense spouse, Sophie. The Webers briefly reappear, now aged and changed. Wendy is a grandmother and Belinda visits with her baby, Maudie. George Weber has a run-in with Crouch, a guest lecturer at George's poly, rebranded as South Medial University. Belinda's catering business falls victim to the recession, disclosed in another episode charting the flagging fortunes of 'Breame & Darke', London art dealers. That setting and the surname 'Darke' were to return, as were other former cameo players, to Simmonds's repertory company and her discrete, evolving 'Posyverse'.

OPPOSITE, ABOVE
'A Christmas Carol' for the *Guardian*, 24 December 1987

OPPOSITE, BELOW
'A Lecture' for the *Guardian*, 20 February 1993

BELOW
A still from the animation for the television documentary *Tresoddit for Easter*, 1991

Gemma Bovery

A few years later, Simmonds wanted to return to making comics for the *Guardian*, but felt the need to stretch herself to a longer story with an ending. The paper offered her a serial in 100 episodes, each one to finish on a cliffhanger to hook readers, and published Monday to Saturday. Inspiration came while holidaying in Italy, where she noticed a pretty young woman: 'She was giving this guy such a hard time by yawning. She looked desperate, surrounded by Prada shopping bags, and she reminded me of Madame Bovary.' The *Guardian* accepted her proposal for a modern, British remake of Flaubert's novel to be called 'Gemma Bovery', altering her name enough from Flaubert's Emma Bovary to hint that her tale might not be exactly the same.

BELOW
Preliminary character studies for *Gemma Bovery*, 1997

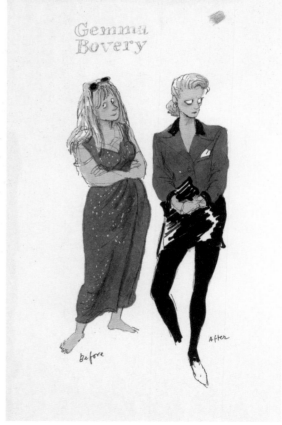

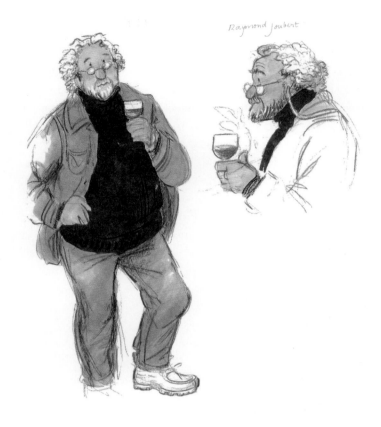

Raymond Joubert

ABOVE

Sketch of the character Raymond
Joubert in *Gemma Bovery*, 1997,
inspired by a man in a Paris bar

Such an ambitious departure would need more time
to plan and produce. Sketchbooks new and old provided
resources for Simmonds to cast characters: 'I had to know
what they looked like, before I could even start imagining
what they would say.' After a rather wistful Victorian false
start on Gemma, she drew her looking seductively out
of the corner of her eye, reminiscent of Diana, Princess
of Wales, and realized that 'The beauty of eyeballs is you
can direct the gaze a lot more than using dots for eyes'.
The bearded baker and bibliophile Raymond Joubert
grew out of a portrait of a man she once spotted in a Paris
bar; several other players derived from tweaking earlier
likenesses. These powers of observation and drawing from
memory had been honed by the drawing course Simmonds
took at Heatherleys, in which she had to look closely at
a model and then rush upstairs to the studio and draw
what she could remember with no further reference. Such

training means Simmonds can cast a character at any time from a concentrated burst of close observation. As for location, beautiful holiday sketches from the South of France suggested Provence, until 'The characters said "No!", because Gemma's husband Charlie Bovery needed to pick up Radio 4 for "The Archers" and the cricket, and to be near London for his kids to visit easily via Eurostar. So it had to be Normandy.' Appropriately, this was the setting that Flaubert's tragic heroine had found equally tedious.

Another issue was the format set by the *Guardian*, vertical this time, but only three columns wide, 'like a giraffe'. Simmonds proved her design panache at collating and collaging diverse visual and verbal configurations into multiple, flexible levels, which operate like a novel's paragraphs, or like the gridded layouts of a newspaper, and result in no two pages looking alike. To convey so much story within 100 episodes, she decided to use more pure prose. Having started by hand-lettering this, by the sixth strip she started afresh and her husband Richard typeset her longhand writing. One unspoken 'rule' of modern comics has been a certain ratio of pictures over words; no cartoonist before Simmonds had conceived of inserting passages of text 'to give readers a rest from the pictures'. 'Gemma Bovery' reinvented the comics medium, by surrounding and counterpointing conventional strips with other perspectives outside the panels: the substantial typeset narration, told in first-person speculative retrospect after Gemma's death by Joubert, obsessed at being unable to save her from repeating Emma Bovary's fate; Joubert's edits of telling, hand-written extracts from Gemma's stolen diaries; accompanying illustrations, mainly without borders, to illuminate the realities and fantasies in these texts; and graphic versions of 'real' objects, letters, photographs, magazine articles, newspaper clippings, etc. The project also saw Simmonds's drawing leap forward, as she applied her experiences from children's books to adult subjects on the newspaper page. Thanks to the *Guardian*'s now superior printing, her delineation in Rotring pen line became more fine and precise. She could also enhance her drawings' realism and sensuality with soft, sometimes smudgy black or grey pencils, watercolour washes and grey felt-tip pens to

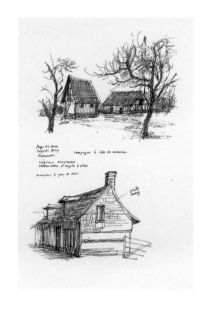

ABOVE
Sketches of houses in Normandy, 1997

OPPOSITE
'Gemma came to hate those Sunday lunches...', Pencil and wash sketch, 1997

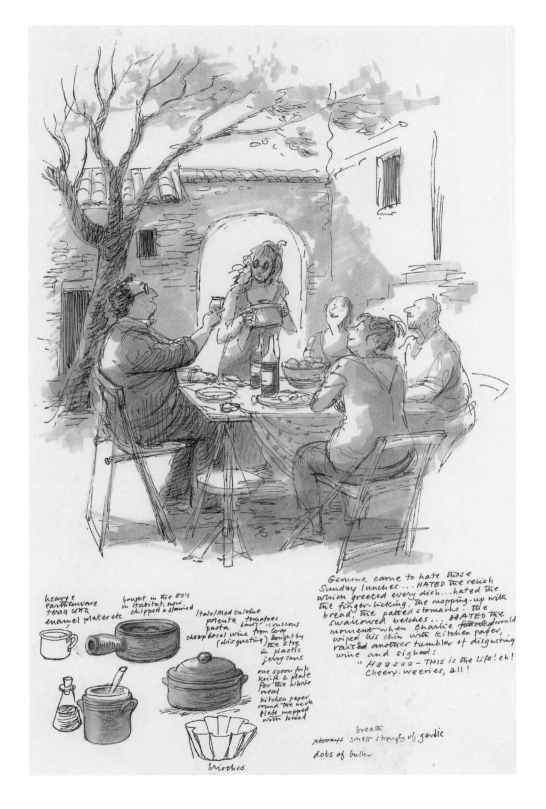

heavy &
earthenware
terra cotta
enamel plates etc

bought in the 80's
in Habitat, now
chipped & stained

Italo/Med cuisine
polenta tomatoes
pasta basil couscous
cheap local wine from Coop
(disgusting) bought by
the litre
in plastic
jerry cans

one spoon fork
knife & plate
for the whole
meal
kitchen paper
round the neck
plate mopped
with bread

brioches

breath
always smelt strongly of garlic

dobs of butter

Gemma came to hate those
Sunday lunches... HATED the relish
which greeted every dish...hated the
the finger-licking, the mopping-up with
bread, the patted stomachs... the
swallowed belches... HATED the
moment when Charlie would
wiped his chin with kitchen paper,
raised another tumbler of disgusting
wine and sighed:
"Haaaaa — THIS is the Life! eh!
Cheery-weeries, all!"

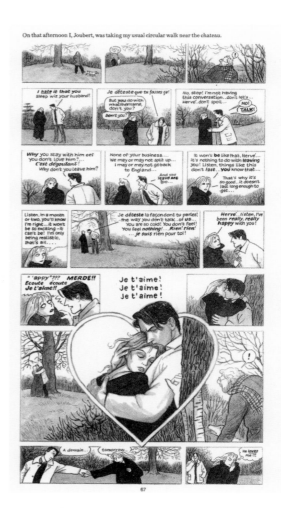

produce modulated half-tones and atmospheric grisaille-like effects. At key moments – notably Gemma with a cold as La Dame aux Camélias, or glowering over her menu at her ex-boyfriend, or embraced by her young French lover inside a heart-shaped panel – this resulted in vignettes of a startling painterly vividness unlike anything in her work before.

To prepare scripts for longer complex stories such as this one, Simmonds uses a landscape A2 sheet of paper divided vertically into three. The right-hand column is for mapping out snatches and sequences of conversation, plot developments and narration. The central, narrower column is for extra thoughts and corrections, and the left-hand one is where everything is refined into the finished script. After

ABOVE

Two pages including more resolved portrayals of characters in *Gemma Bovery*, 1999

ABOVE
A three-column A2-size sheet for planning the script of *Gemma Bovery*, 1999

completing forty episodes, Gemma Bovery's preparation was interrupted, when Simmonds was incapacitated by a nasty fall. The delay actually helped her clarify her characters' motivations and feelings. Back at the drawing board, she roughed out a scene of Gemma's suicide, in line with what Emma had done, only to find that her heroine simply refused to kill herself. This forced Simmonds to think harder and find another denouement.

The daily serialization in the *Guardian* began on Monday, 19 April 1999 as 'The Late Gemma Bovery', subtitled 'A tale of adultery and soft furnishings narrated by Raymond Joubert', and timed for Jonathan Cape's book compilation for the pre-Christmas market. After publication had started, she had to ditch several episodes because they deviated too much from the main story. One showed Gemma having to be stepmother to Charlie's kids and comparing her difficulties with those of her own stepmother in the 1970s.

The handwritten text within the image (Gemma's diary and marginal notes):

Gemma's diary

August 30
I was nearing screeching point ... but then, thank God, everyone left (about 12·30, rather pissed). Persuaded Charlie to go to bed — I just had to be alone. I was in a completely manic state — washed up stack of plates twice.

Dinner — what anybody said, did, what the food was like is *total total blank*. Have spent a fortune & three days knackering myself cooking and I can't remember ANYTHING! Whole evening I was on auto pilot. In shock. Could only think of him. Hervé. (this morning I didn't even know his name) It's all so sudden. Weird. Strange. Finding ourselves on the floor like that ...
yesterday

And just as strange for me, Joubert to read in her diary *now about it* the secret she concealed so well that evening — concealed, that is, until I, the trained decoder, saw their lovebite on her neck

I often regret now I ever saw it. But for that lovebite, my interest in Gemma would have probably waned ... and things might not have ended in grief. But I saw it ... *as transfixed! Not just a .. is proof of illicit love* It was t'so, I remember *e.g. the perfect exampl' a SIGN...*
Ah...

du the evening of her dinner

and was transfixed — not just excited excitement about of her illicit affair with Hervé it was also I remember thinking a perfect example of a sign.

robotic politesse
190
170

voluptuous

2 1

It was the first perfect example of a sign.
If you'd ask me what a love bite was before the one I saw on Gemma's neck I would have said ...

Roughs for Gemma
The dinner party
Hervé
53/54 in book

looking at Sammier at all the men as if she loved them .

In another, 'I had a plan for Charlie to make a cricket pitch and have some expat matches.' Painfully jettisoning these detours meant that Simmonds fell behind and near the end was up to the wire, sending the final episodes first to the printers of the graphic-novel edition, before they had been published in the paper. All her efforts proved worthwhile,

ABOVE AND OPPOSITE

A pencil layout that evolved into scenes on two separate pages in *Gemma Bovery*, 1999

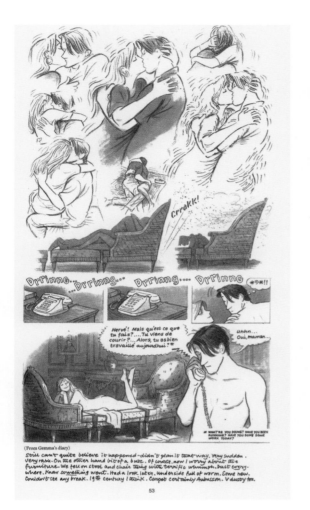

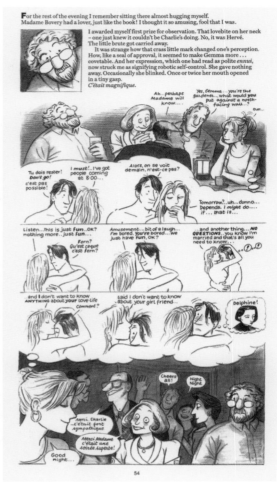

however. The book *Gemma Bovery* was a major commercial and critical success, and the foreign editions, the first of Simmonds's adult work, starting with a French translation in 2000, and an American version in 2005, finally brought her the international audience and acclaim she deserved. Although a few testy French critics struggled to accept the book as a '*bande dessinée*' or conventional comic, labelling it a '*roman illustré*' or illustrated novel, *Gemma Bovery* stands indisputably as a dense, multi-voiced, yet always clear and compelling graphic novel.

OVERLEAF

Two unused episodes of *Gemma Bovery*, one without typeset text, the other finished, 1999

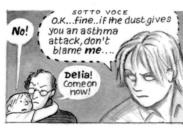

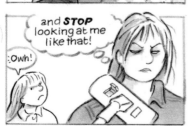

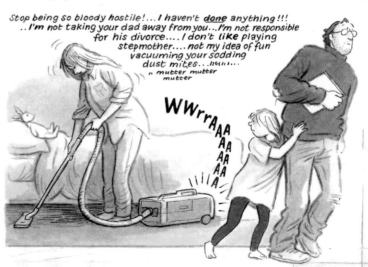

Two days later Charlie returned the kids to London. On Sunday he was back. I remember watching him walking up and down the middle of old Taillefer's field with another *anglais*, Monsieur Parkin, a good customer of mine (when he's in France). He has a Range Rover (*avec toutes les options*), and spent a packet doing up his house here.

The field was, and still is, a sore point. It had always belonged to my family. But after the Great War my poor widowed grandmother let the Taillefers have it for a pittance. Things were very sour after that. Last year, when old man Taillefer went into the home in Rouen, the daughter refused even to consider my offer. She sold it to the English, along with the house and garden and screwed our plan to extend my organic vegetables.

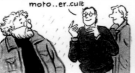 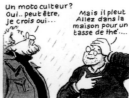 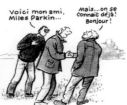

The Boverys had never asked me in before. Of course, I knew the house from old Taillefer's time. I saw no real improvements. The same smell of damp and drains, but now overlaid with pot pourri. There was no sign of Gemma, but the dog Carrington sniffed my shoes.

I was given tea (vile, dark ginger, made with a bag). The glass of wine wasn't bad at all. They talked about the rain. I told them that Rouen was known as the "*pot de chambre de la Normandie*". Then I asked Charlie about the field – what he proposed – turn the old barn into a *gîte* for tourists? That's what people did. Miles Parkin said he was trying to persuade Charlie to play cricket there. I laughed. "*Vous allez jouer au cricket, tous les deux?*" But it wasn't a joke. They were planning an elaborate enterprise: Miles knew many *anglais*, some from nearby. A certain length of coconut matting would be laid down. They assured me that a barrier of net would prevent my vegetables being struck by balls.

The whole thing sounded *emmerdant*. I said I should be off. Charlie would find a motoculteur by looking in the *pages jaunes*.

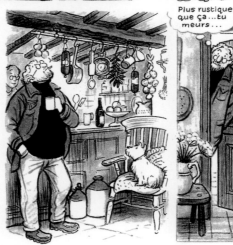 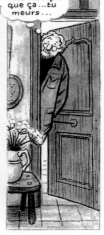

At that moment a rhythmic shunting began in the bedroom overhead, increasing in tempo, until the whole ceiling thrummed. Gemma's voice could be heard, panting *"Je viens, tu viens, il vient . . ."*

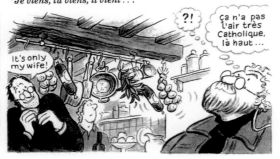

'Literary Life'

Between 2002 and 2004, Simmonds returned to regular strips by contributing to the *Guardian*'s Saturday Book Review supplement. Under the umbrella title 'Literary Life', she enjoyed targeting every aspect of the idiosyncratic world of book publishing.

> *I am on the edge of it, so I know about the terrible vanities. I was free to choose which character was going to appear each week and whether it would be a comic strip or a single drawing. That depended on what idea I had on the Monday. I had to deliver my drawing by Wednesday, but I never worked in advance, I preferred the tyranny of the final deadline for an idea to turn up.*

This is reflected in her more relaxed line-work in black ink, often overlaid with grey washes.

Among her cast, cantankerous J. D. Crouch grumbled on, joined by gruff, bushy-eyebrowed Welsh writer Owen Lloyd. The original 1950s 'Silent Three' schoolgirls returned to pass anachronistic comments on current fiction as 'The Literary Three'. Another recurring series, 'Facts and Fallacies', made digs at how the public misunderstands authors of children's books, like herself: 'Oh, what fun! Do you ever do any serious writing?' One week Simmonds showed a sinister Addams-esque twist to a classified advert for a perfect writer's solitary retreat called 'Fairy-tale Cottage', whose woodshed harboured a mad, axe-wielding gnome. Her cover for the French edition, also used on merchandise, proved how passionate the French are for reading, even topless on the beach. Throughout, Simmonds demonstrated her ever-growing arsenal of drawing, writing, lettering and design abilities, appropriate to each subject of her satire.

OPPOSITE
'Paradise' from the series 'Literary Life' for the *Guardian*, 29 May 2004

PAGE 78
Pencil layout for an episode introducing writer Owen Lloyd, from the 'Literary Life' series for the *Guardian*, 5 October 2002

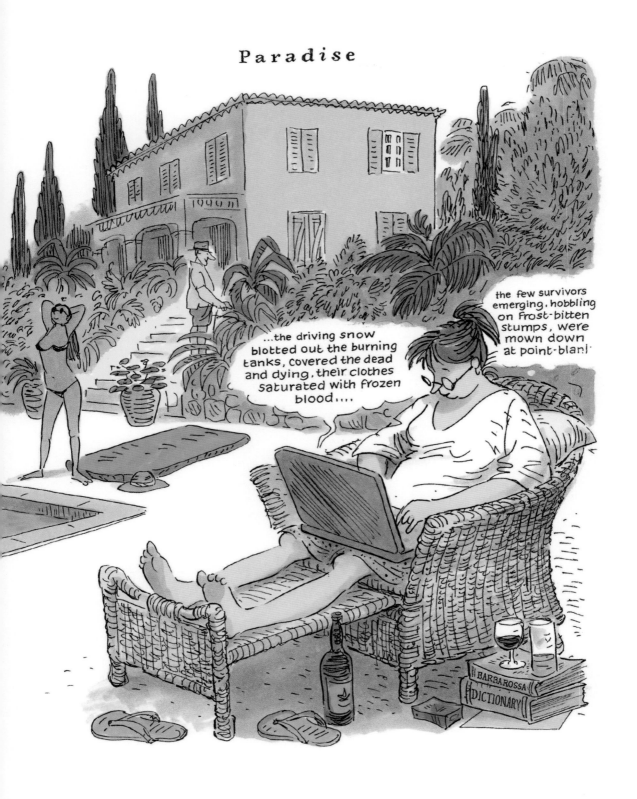

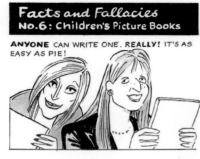

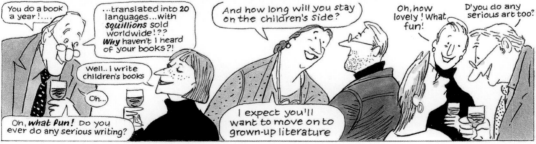

ABOVE

'Facts and Fallacies No. 6: Children's
Picture Books', from the series 'Literary
Life' for the *Guardian*, 17 May 2003

Tamara Drewe

'Literary Life' planted seeds that blossomed in 2005 into *Tamara Drewe*, Simmonds's second serialized graphic novel, not least the egos and libidos of writers as core themes, and its setting in Stonefield, a former country farm, now an upmarket writers' retreat run by best-selling author and womanizer Nick Hardiman and mostly by his dedicated wife, Beth. Stonefield may be far bigger than Fairy-tale Cottage but it hides its share of secrets. This time, her nineteenth-century literary allusions were to Thomas Hardy's 1874 novel *Far From The Madding Crowd*, transposed to class-divided, celebrity-obsessed contemporary Britain. It also saw Simmonds finally applying her flair for full-colour artwork to long-form adult comics. Again, its gestation period involved much sketching to find her all-new cast. Hardy's heroine was

BELOW
Character studies for Andy Cobb and for Nick and Beth Hardiman, *Tamara Drewe*, 2004

OPPOSITE
Early character studies for *Tamara Drewe*, 2004

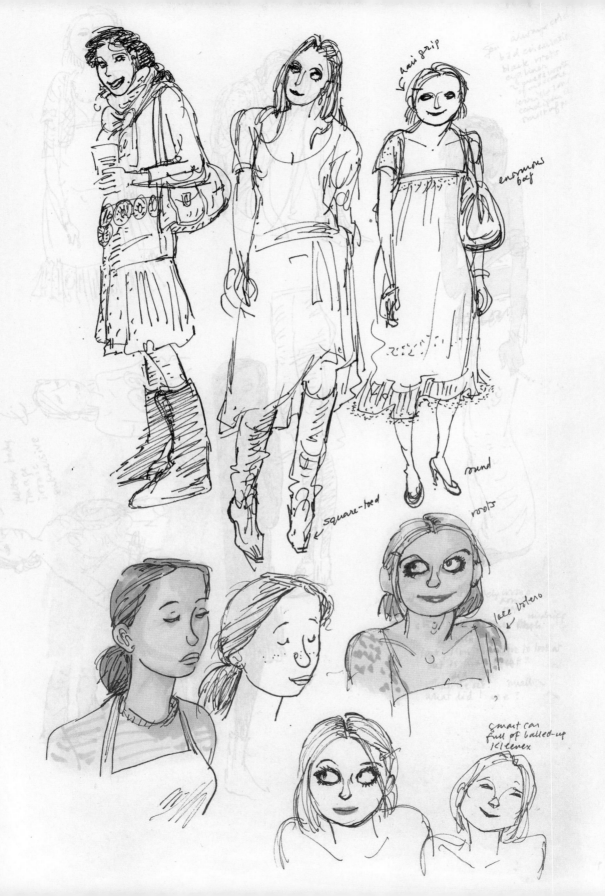

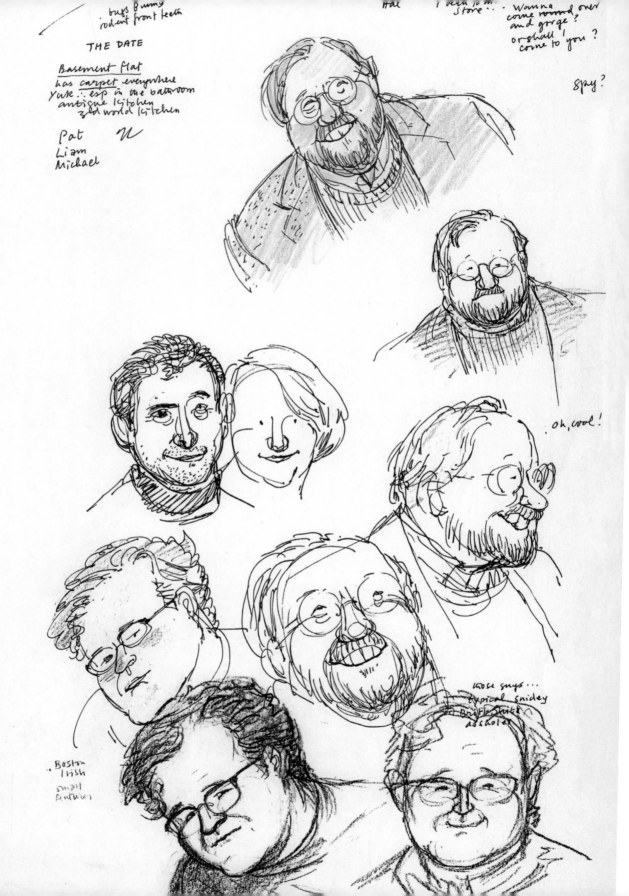

bugs Bunny
rodent front teeth

Hal

I been to the
store...

Wanna
come round over
and gorge?
or shall I
come to you?

spay?

THE DATE

Basement flat
has carpet everywhere
Yuk... esp in the bathroom
antique kitchen
3rd world kitchen

Pat
Liam
Michael

oh, cool!

those guys...
typical snidey
BrisFl. Staff
asshole

Boston
Irish
small
features

called Bathsheba, after King David's wife in the Bible, so Simmonds chose Tamara Drewe's name from Tamar, David's daughter, whose beauty is a curse. And her surname? 'Drew is the past tense of draw, so she is a catalyst, she draws people towards her.'

When Tamara inherits her childhood home in the country, she returns, a former wallflower now stunningly transformed by a 'nose job', and turns the heads of four rival males. To cast Beth Hardiman, Simmonds arrived at her face after various guises: 'I don't use photographs. It's out of my head. I start with the eyes. I think about how old she'd be, and the 1980s flicky-up hairdo she'd still have, even though she's put on weight since then.' Other players developed from earlier sketchbooks, such as the American academic Glen Larson, whom she once spotted in a lecture for having 'such American hair'. She acknowledges that certain types reappear in her comics, 'as if I had a repertory company of physical types to play different roles'.

OPPOSITE

Early character studies of Glen Larson, *Tamara Drewe*, 2004

BELOW

Watercolour of landscape in Dorset prepared for *Tamara Drewe* in 2005 and used as one of the title illustrations for the BBC television adaptation of *Cranford,* 2007

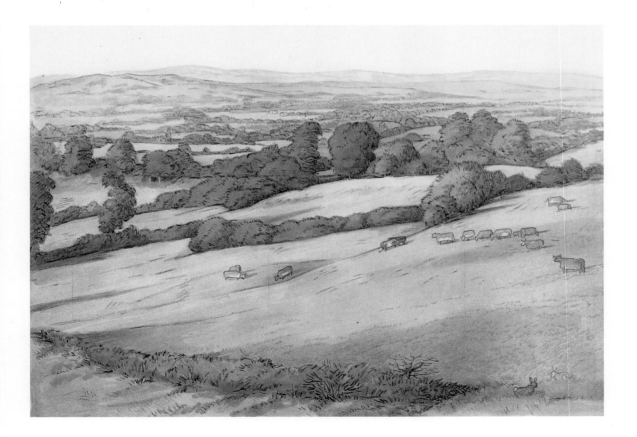

Casey:

After Jody sent her stupid e-mail, we kept away from Winnards Farm. I don't know what we expected to happen – the police testing Tamara's laptop for fingerprints, sussing us, coming round and doing us for breaking in. Well, that didn't happen, but we should be careful. I mean, we're back using the old bus shelter, where you get a good view up the lane. Today we saw the old writer guy from Stonefield go past Winnards Farm – very slowly, like he was really really interested.

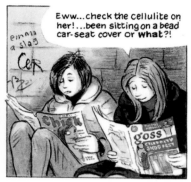

I tell Jody we should hang out somewhere else, and she goes, "Like where, your bloody bedroom?" Which is true. It's so-ooo boring, this village. Nowhere to go, nothing to do. Nothing happening, except when Gary Pound and his mates nearly set fire to the Coronation Tree on the green.

So, I'm thinking OK, might as well go home, do some homework, because Jody's getting up my nose, too. She's droning on about Ben, Ben all the time. But if I even mention Ryan or boys at school she starts dissing them, treating me like a moron.

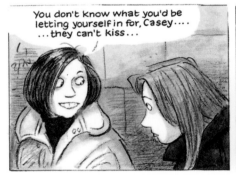

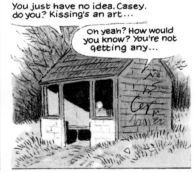

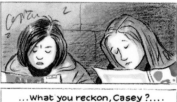

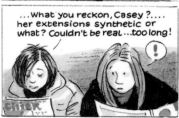

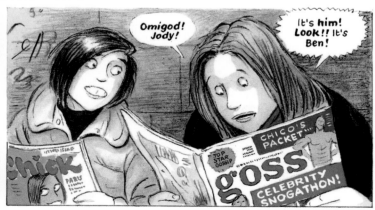

Tamara Drewe's setting in the village of Ewedown is almost a Dorset equivalent to Tresoddit, a rustic community invaded by moneyed outsiders. Simmonds confronts a number of unsettling concerns about the divide between city and countryside, and portrays with empathy the challenges facing British youngsters through two local working-class teenagers, Jody and Casey, desperate to escape their dull, 'event-proofed' village. 'I wanted a counterpoint to the country being a wonderful place for a weekend cottage. For the indigenous population there's no bus, no post office, the pub lingers on. So the girls are a kind of chorus.'

The *Guardian* granted Simmonds 100 episodes (she would finally need 110), once more in the Saturday Book Review. She organized her layouts around a flexible grid of five horizontal rows, in which to incorporate typeset texts, illustrations and assorted graphic elements such as pages from celebrity gossip magazines or websites. She used three different typefaces to distinguish the internal monologues of her three narrators, Glen, Beth and Casey, while Tamara's public persona, but not her private thoughts, came through facsimiles of her newspaper diary column. The serialization of two episodes a week debuted on 17 September 2005, before Simmonds had enough advance episodes ready, so she fell more and more behind:

> *I know vaguely what is going to happen, and I hope it's enough to keep it going. It is terrifying riding something that is still hatching and by the end, I was only two weeks ahead. That meant making decisions very quickly and rashly.*

Her painstaking care included working out the interior floor plans of the locations to maintain a consistent, convincing world.

Luckily, after its conclusion in December 2006, Simmonds had time to re-colour her artwork more subtly and radically improve her story for the book edition released in November 2007. She reworked almost half the episodes, expanded several scenes and added a dozen new pages. Between the newspaper and graphic-novel versions of Tamara's bombshell entrance, Simmonds removed her green wellies

OPPOSITE
Teenagers Jody and Casey
from *Tamara Drewe,* 2006

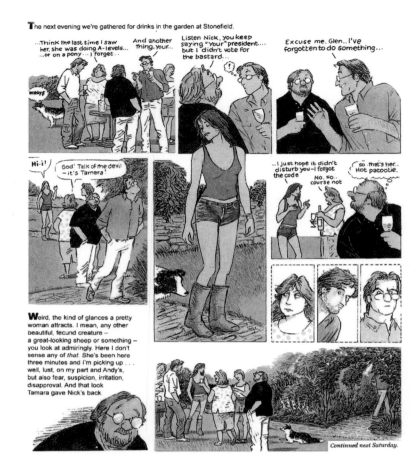

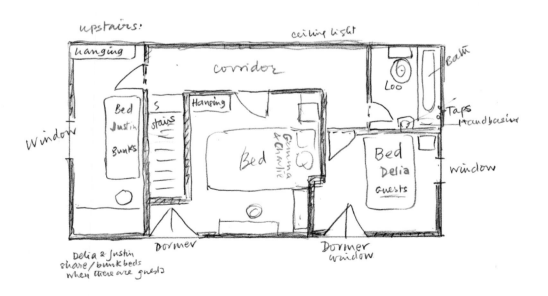

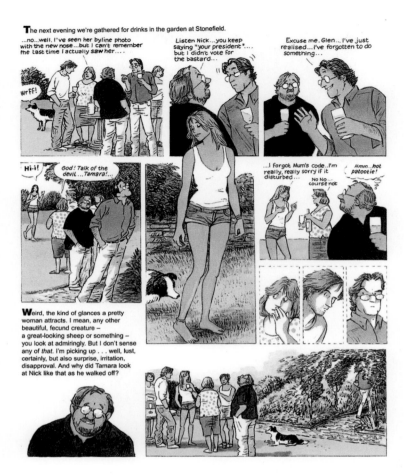

and instead showed her more sensuously, barefoot on the grass. This minor change facilitated an extra page to deepen Glen's instant infatuation with 'Princess Charming', which spurred him to try gallantly carrying shoeless Tamara over the gravel, only to be brusquely rejected. Glen grew into the graphic novel's overarching narrator through the male gaze and a more prominent protagonist, disclosing his secret affections for Beth and his part in the death of a central character. In the newspaper, Simmonds had shown how this death occurred too clearly, so to heighten the tension in the book she portrayed only its tranquil aftermath of a distant corpse in the setting sun. Darker still, and reported rather than shown, was the demise of another character, Simmonds's reflection on adolescent anomie. *Tamara Drewe*

OPPOSITE, ABOVE AND THIS PAGE

Tamara Drewe makes her first appearance, in the *Guardian* in 2006 and right, more sensuously, barefoot in the revised graphic novel in 2007

OPPOSITE, BELOW

For her own reference purposes, Simmonds makes detailed floorplans. This one is for Gemma Bovery's Normandy house, 1998

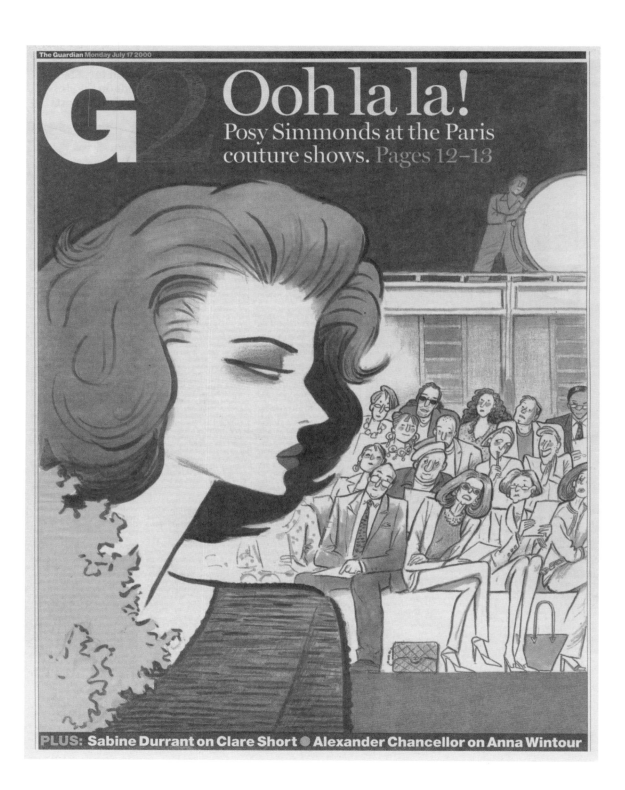

went on to be translated into nine languages and transferred swiftly in 2010 to the big screen, although director Stephen Frears omitted the story's second death, preferring a happy-ever-after ending.

As a balance to substantial projects like *Tamara Drewe*, Simmonds takes on more modest assignments on the side. These challenges have included searingly perceptive reportage pieces for the *Guardian*, for example based on her accompanying the three main parties in the 2001 general election on their campaign trails, and her visits to Paris Fashion Week. In 2002, the Hayward Gallery in London asked her to contribute – as the only contemporary artist – to their touring exhibition *Followers of Fashion: Graphic Satires from the Georgian Period* (2002), which displayed her hilarious chart of lifelong modern male attire. For the small screen, Simmonds drew the title graphics for the BBC's *Cranford* in 2007, based on the work of Elizabeth Gaskell. In 2013, she created for the *Guardian* the 'interactive fairytale' *King Ironsides*, which can be enjoyed as a sixteen-page printed supplement or an online, page-turning 'webcomic'.

OPPOSITE AND BELOW
Cover and double-page spread of a report about the Paris fashion shows for the *Guardian*, 17 July 2000

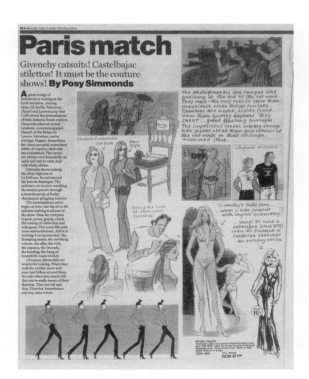

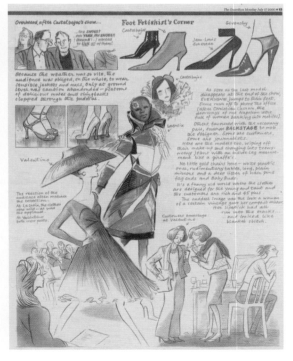

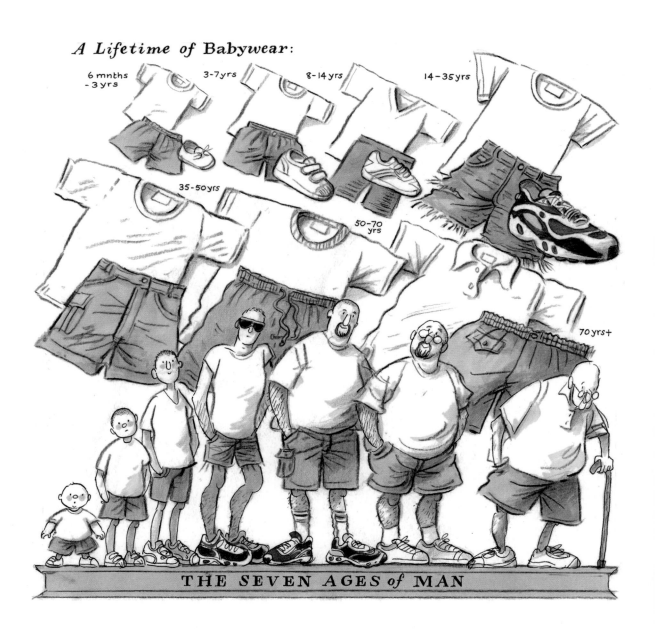

A *Lifetime of Babywear*:

6 mnths
- 3 yrs

3-7yrs

8-14yrs

14-35yrs

35-50yrs

50-70
yrs

70yrs+

THE SEVEN AGES *of* MAN

'The Seven Ages of Man' for
the Hayward Gallery touring
exhibition *Followers of Fashion:
Graphic Satires from the Georgian
Period*, 2002

In this, she recast Margaret Thatcher's rise to power into a faded book of mock-Arthurian fantasy prose and acerbic, linear caricatures. In Simmonds's first foray into advertising, Cartier in Paris commissioned her in 2014 to create a five-page story for their limited edition anthology of comics to promote their women's watch Ballon Blanc. And in her many sketchbooks lie some works-in-progress, self-generated and so far unseen. Simmonds felt compelled to react to the wars in the Middle East.

The families of British casualties, when interviewed, often had photographs of their sons or brothers as children on view. I also thought about it from an Afghan or Iraqi point of view. All mothers' sons, in a totally pointless war.

She responded with disturbing portrayals of vulnerable boys, wearing combat uniform, smoking, swearing, and dying like grown men.

BELOW

Caricature of Margaret Thatcher from *King Ironsides*, a webcomic for the *Guardian*, 13 April 2013

OVERLEAF

The second and third pages of the five-page comic from the *Ballon Blanc* anthology for Cartier, 2014

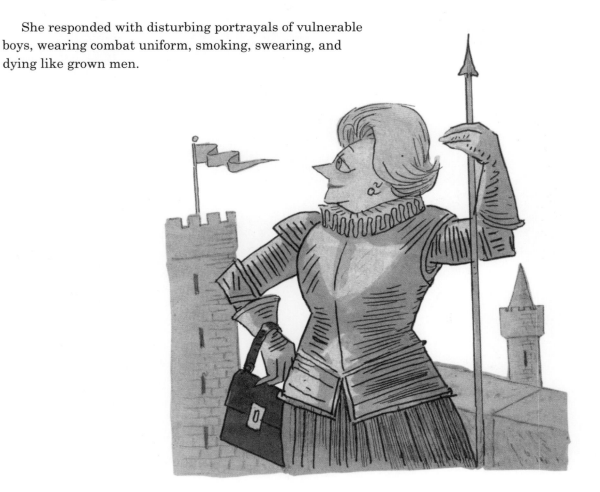

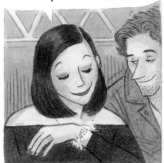

Beautiful! I'm overwhelmed!... but you shouldn't have...

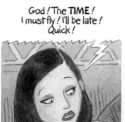

God! The **TIME**! I must fly! I'll be late! Quick!

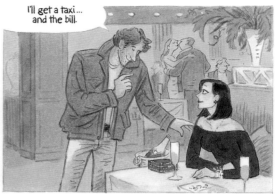

I'll get a taxi... and the bill.

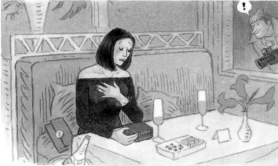

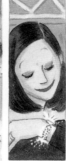

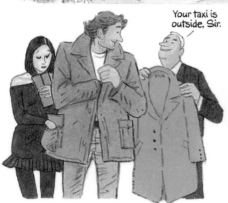

Your taxi is outside, Sir.

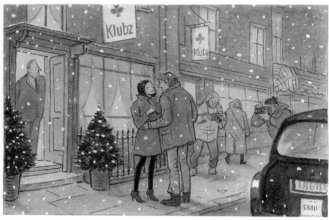

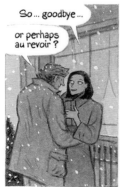

So... goodbye...

or perhaps au revoir?

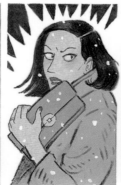

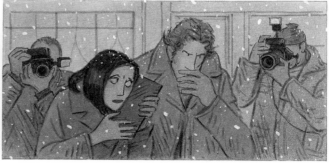

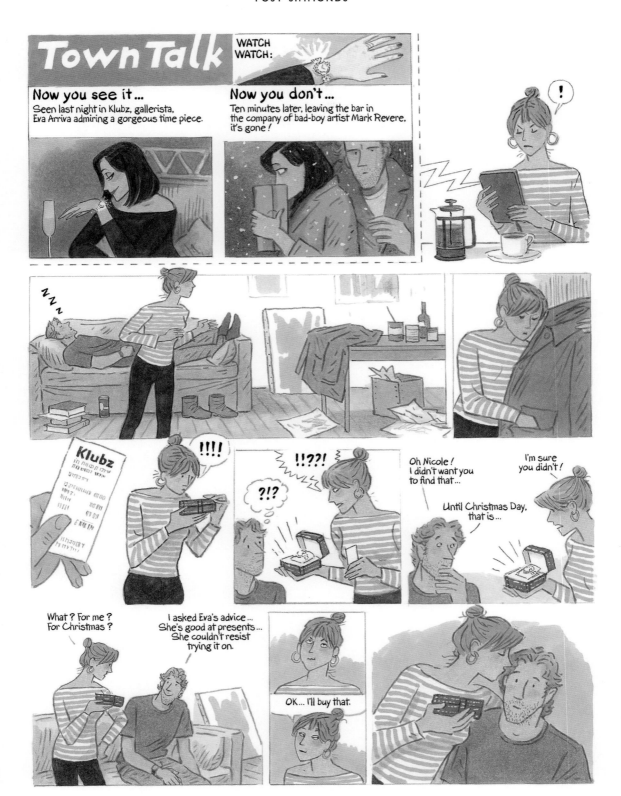

any loss of life is/
was a cause
for deep regret

private John Hicks
Garmsir

Lance Bombadier —
Guardsman
Trooper
Lance Corporal

"There are no
victors in this war"

died bravely
doing his duty

looked like he
was sleeping

A third British
soldier was
killed yesterday

sleeping like a baby

his relatives have been
informed

not named until
his relatives have been
informed.

OPPOSITE AND ABOVE
Studies from Simmonds's
sketchbook for an unpublished
project in response to the Iraq and
Afghan wars, *c.* 2003 and after

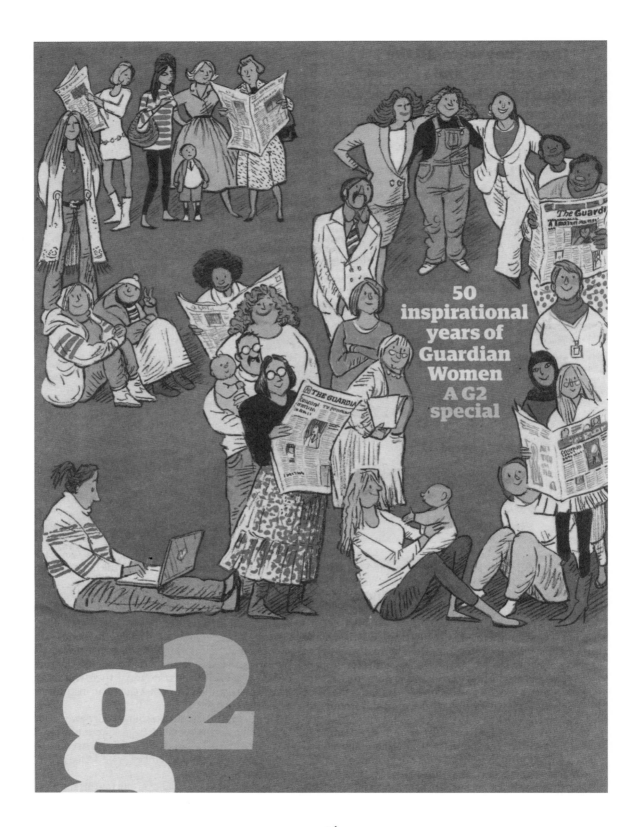

50
inspirational
years of
Guardian
Women
A G2
special

g2

Cassandra Darke

In 2007, the *Guardian*'s Women's Page, Simmonds's home for many years, reached its fiftieth anniversary. She drew the cover, the numbers 5 and 0 forming two lines of women through the decades, including Wendy Weber, with husband George and baby Benji. Summing up how far British women have really progressed over this time, Simmonds says succinctly, 'Things are much better, the same and worse'. This state of affairs underpins her 2018 graphic novel *Cassandra Darke*. In contrast to Gemma and Tamara, her attractive, young leading ladies in the countryside, Cassandra Darke is an old, overweight, upper-class, divorced London art dealer, who lives comfortably alone in Chelsea in a cold, unglamorized London.

'My first idea was I wanted to draw and write about winter. I sketched the wintry Cassandra Darke in her winter years, rich and privileged, who makes sure she doesn't feel "The Cold" in life.' Outwardly, she resembles Mrs Scrooge, the subject of a seasonal poem inspired by Charles Dickens's *A Christmas Carol*, by Carol Anne Duffy, which Simmonds illustrated for the *Guardian* in 2008. 'For that I reread *A Christmas Carol*, and the two ideas came together. I didn't want to follow Dickens's plot. I borrowed some of the story's mood and shape, but they are deeply buried.' She centred the story around two Christmases and made Cassandra Darke an unlikely and unlikeable anti-heroine, without partner, children or friends, happiest in her own company, close only to her pug Corker. Despite being turned into a social pariah for her conviction for defrauding her former husband's gallery, Cassandra shows no remorse or self-pity – 'Compared with double murderers, one almost feels like Snow White.'

Production of *Cassandra Darke* marked Simmonds's cautious step into working digitally. Previously, her graphic novels were put together with Richard Hollis, who typeset each piece of text to be stuck down onto the artwork with Magic Tape or adhesive wax. For this book, although Simmonds still made her artwork entirely by hand in pencil, inks, crayon, gouache and felt-tip on paper, Hollis and an assistant assembled her images and texts on

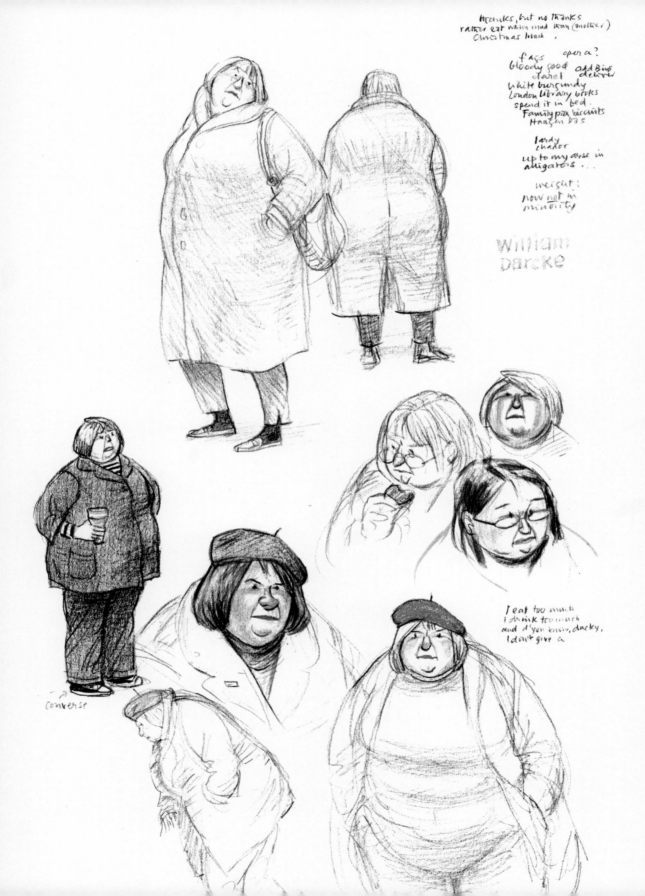

thanks, but no thanks
rather eat warm mad keen (mother)
Christmas lunch.

fags opera?
bloody good odd Bix
 claret deprive
white burgundy
London Library books
spend it in bed
 Family pax biscuits
 Haagen Das

 lardy
 chader
up to my arse in
alligators...

 weight!
now not in
minority

William
Darske

I eat too much
I drink too much
and d'you know, ducky,
I don't give a

Converse

OPPOSITE AND RIGHT

Preparatory character studies
for Cassandra Darke, 2014

BELOW

Finished drawing of
Cassandra Darke, 2014

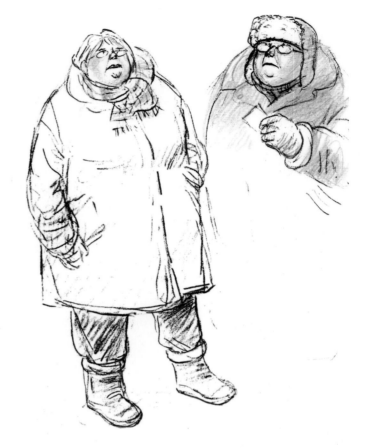

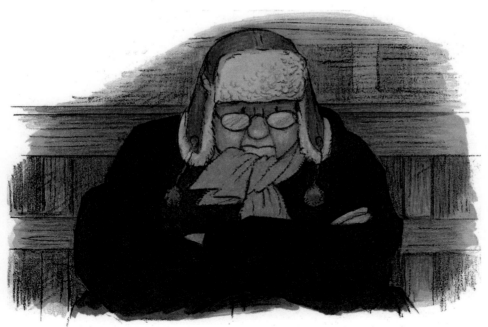

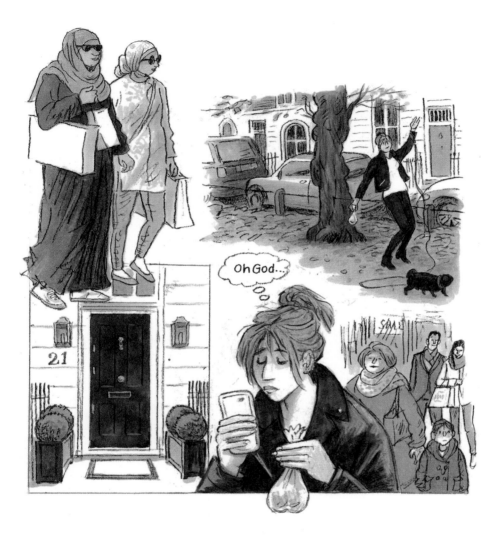

computer, streamlining corrections, colouring adjustments and cleaning-up. Other departures were the introduction to her graphic novels of resplendent whole-page, full-bleed images of 'emphatic Christmas scenes' and her Conté crayon technique on textured watercolour paper. She found 'it's good for foggy, dusky atmosphere', and its swathes of rough grey over interiors and streets reinforce the seedy *noir* tone.

Beneath the humour and beauty of Simmonds's work often lies a depth of empathy and a fearlessness to acknowledge the disappointments and disasters in life. In this respect, *Cassandra Darke* is noticeably darker and more inclusive than her previous books, in response to Simmonds's concern that 'Life has got grimmer for many,

ABOVE
An early version of a scene showing Nikki walking Cassandra's pug Corker in Chelsea, *Cassandra Darke*, 2017

OPPOSITE
A scene set in London's diverse East End, from *Cassandra Darke*, 2018

Lowbridge Road has little to recommend it – a long noxious thoroughfare surrounded by streets of decaying semis.

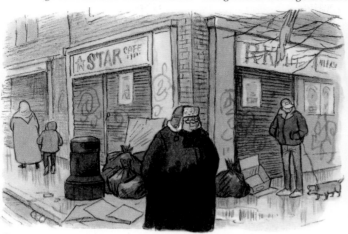

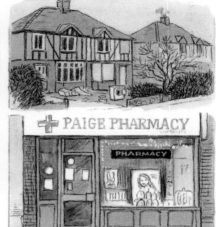

I have no real plan, except to patronise a few shops and ask questions about the area, starting with the chemist where the paracetamol came from.

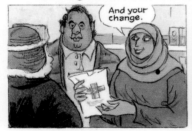

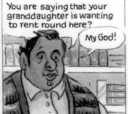

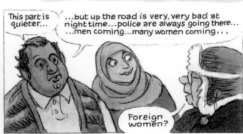

In the chippy the woman shrugs and says she is new to the area, but the next shop, where I buy half a bottle of scotch, is more rewarding.

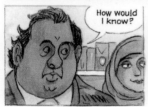

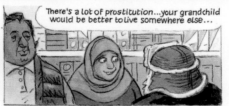

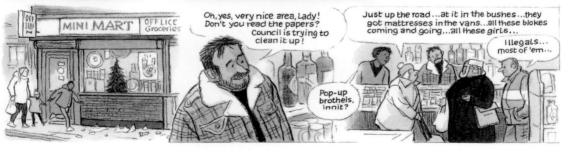

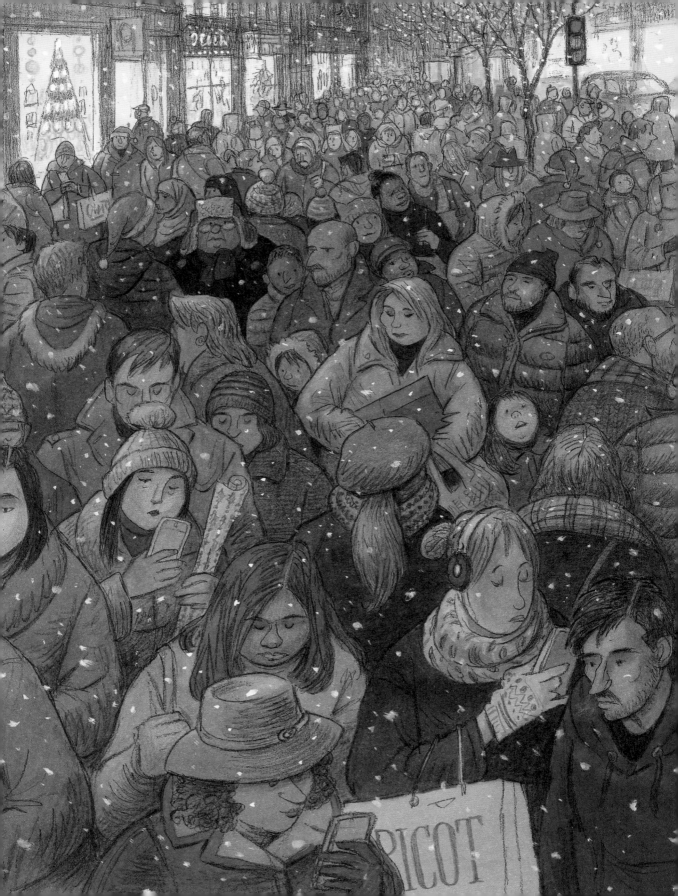

many people. Living in London, you're aware of two worlds: the gritty one, and the very glitzy one.' She takes Cassandra, the sort of plain, older, single woman who can be invisible in today's society, and makes her the first-person narrator and agent of her own story. She fosters in the reader genuine understanding for this affluent misanthrope – for what she has lost, what she has never had, and what she is still capable of, with the help of some yellow rubber gloves.

For over fifty years, London has been Posy Simmonds's home, its people, places and stories a crucible of her creativity. She has come to occupy a unique role as a fiercely truthful observer of British life, predominantly of the white British middle class, to which she herself belongs, through her miniaturist's gimlet gaze. Widely acclaimed, she has twice been chosen as both Cartoonist of the Year in the British Press Awards and Strip Cartoonist of the Year in the Cartoon Art Trust Awards. In 2001, Raymond Briggs speculated in the *Guardian*, 'Does it mean that we will live to see an ancient Dame Posy Simmonds go tottering by?'

I grew up in the country but have been a Londoner for over 50 years. I live in a late Georgian square quite near the centre.

My London Posy Simmonds

Old Neighbours:
● **Charles Dickens** lived at 48 Doughty Street WC1 (now the Charles Dickens Museum). He wrote "Oliver Twist" here.

● **V. I. Lenin** lived at 30 Holford Square WC1 in 1902/3. The square was bombed in 1941. After the war, the Russian émigré architect, Berthold Lubetkin, designed a social housing project on the site. It was originally called **Lenin Court**, but when the Cold War began, the building was re-named after the politician, Ernest Bevin - requiring a change of just two letters.

46

● Two very agreeable places: Andrew Edmunds, 46 & 44 Lexington Street W1.
46 is a cosy, candle-lit bistro. Above is the Academy — a tiny members' club....
....impeccably rakish.
44 is a paradise for lovers of antique prints.

● Visitors to my garden:

● L. Cornelissen
– a great art shop.
105 Great Russell
Street, WC1

Ⓤ Westminster: favourite
Tube station. Stainless steel, soaring
beams. Like a Piranese etching.

I walk most afternoons – looking at buildings, window-shopping, people-watching.
Sometimes in thrumming crowds... sometimes in London's many green spaces.

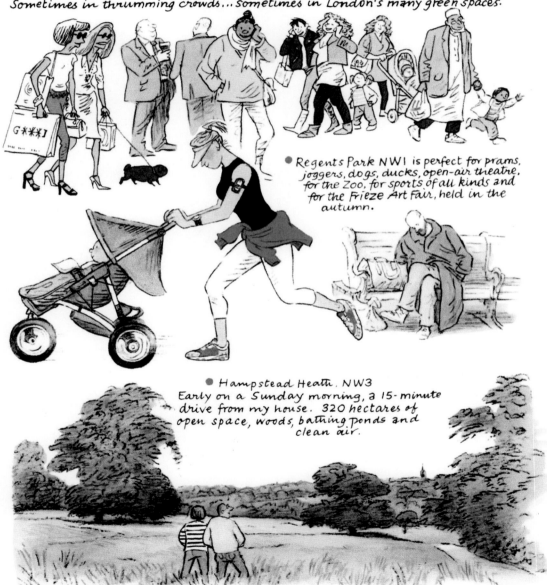

● Regents Park NW1 is perfect for prams,
joggers, dogs, ducks, open-air theatre,
for the Zoo, for sports of all kinds and
for the Frieze Art Fair, held in the
autumn.

● Hampstead Heath. NW3
Early on a Sunday morning, a 15-minute
drive from my house. 320 hectares of
open space, woods, bathing ponds and
clean air.

Roger Scruton

Charles ...

Laurence Kelly
Linda Kelly

Margaret MacMillan
Hugh Thomas

Karen Armstrong

Jonathan Bate

Raymond Briggs
Carol Ann ...

Richard ...

Nell Dunn

Andrea Levy

Anthony Rudolf

Posy Simmonds

OPPOSITE
Simmonds's signature in the
Royal Society of Literature's roll
book, 2004

BELOW
Posy Simmonds photographed by
David Levene for the *Guardian*,
2018

In fact, the following year, she was awarded an MBE for her
'services to the newspaper industry'. In 2004, Simmonds
joined Briggs as only the second writer in pictures and
words to be made a Fellow of the Royal Society of Literature.
At the ceremony, inductees have a choice of illustrious
writing implement with which to inscribe their names in
the Society's vellum roll book. Naturally, Simmonds chose
the original quill pen of Charles Dickens. Like a handshake,
and like passing on the baton.

Books written or illustrated by Posy Simmonds

Baker Cat, Posy Simmonds, Jonathan Cape, 2004

Bear by Posy, Posy Simmonds, Mayflower, 1974

Bouncing Buffalo, Posy Simmonds, Jonathan Cape, 1994

Captain Hook Affair, The, Humphrey Carpenter, Allen and Unwin, 1979

Cassandra Darke, Posy Simmonds, Jonathan Cape, 2018

Cat Among the Pigeons, Kit Wright, Kestrel, 1987

Cautionary Tales and Other Verses, Hilaire Belloc, Folio Society, 1997

C. O. Jones Compendium of Practical Jokes, The, Richard Boston, Enigma Books, 1982

Concise History of the Sex Manual, A, Alan Rusbridger, Faber & Faber, 1986

Folio Book of Humorous Verse, The, edited by Edward Leeson, Folio Society, 2002

Fred, Posy Simmonds, Jonathan Cape, 1987

Gemma Bovery, Posy Simmonds, Jonathan Cape, 1999

Grass Beneath the Wire, The, John Pollock, Anthony Blond, 1966

Great Book of Mobile Talk, The, Andrew Barrow, Square Peg, 2013

Great Shakes!, Kit Wright, Viking, 1994

Helping Your Handicapped Child: A Step-By-Step Guide to Everyday Problems, Janet Carr, Penguin Books, 1980

Hot Dog and Other Poems, Kit Wright, Kestrel, 1981

Lavender, Posy Simmonds, Jonathan Cape, 2003

Literary Life, Posy Simmonds, Jonathan Cape, 2003

Literary Life Revisited, Posy Simmonds, Jonathan Cape, 2016

Lulu and the Chocolate Wedding, Posy Simmonds, Jonathan Cape, 1990

Lulu and the Flying Babies, Posy Simmonds, Jonathan Cape, 1988

Matilda, Who told such Dreadful Lies, Hilaire Belloc, Jonathan Cape, 1991

More Bear by Posy, Posy Simmonds, Mayflower, 1975

Mrs Scrooge, Carol Ann Duffy, Picador, 2009

Mrs Weber's Diary, Posy Simmonds, Jonathan Cape, 1979

Mrs Weber's Omnibus, Posy Simmonds, Jonathan Cape, 2012

Mustn't Grumble, Posy Simmonds, Jonathan Cape, 1993

Pick of Posy, Posy Simmonds, Jonathan Cape, 1982

Poems, 1974–1983, Kit Wright, Hutchinson, 1988

Posy Simmonds Bear Book, The, Posy Simmonds, Berkeley, 1969

Pure Posy, Posy Simmonds, Jonathan Cape, 1987

Rabbiting On, Kit Wright, Young Lions, 1978

Tamara Drewe, Posy Simmonds, Jonathan Cape, 2007

True Love, Posy Simmonds, Jonathan Cape, 1981

True Love (digital edition), Posy Simmonds, Sequential, 2016

Very Posy, Posy Simmonds, Jonathan Cape, 1985

Women's Rights: A Practical Guide, Anna Coote and Tess Gill, Penguin, 1974

Young Visitors, The, Daisy Ashford, Chatto & Windus, 1984

Books to which Posy Simmonds contributed

Book 'im! 70 Years on the Game: A Tribute for Bernard Stone from his Many Friends, privately published, 1974

Book of Other People, The, edited by Zadie Smith, Hamish Hamilton, 2007; Posy Simmonds illustrates 'J. Johnson', a short story by Nick Hornby

Farms for City Children, Charity Calendar, 2017 & 2018

Followers of Fashion: Graphic Satires from the Georgian Period, Hayward Gallery, 2002

Publications about Posy Simmonds

Barker, Martin, 'POSY: Three go mad in the *Guardian*', *Magazine of Cultural Studies*, 5, (1993), pp. 16–19

Constable, Liz, 'Consuming Realities: The Engendering of Invisible Violences in Posy Simmonds's "Gemma Bovery" (1999)', *South Central Review*, 19/20 (2002), pp. 63–84

Ho, Elizabeth. 'From "Having it all" to "Away from it all": Post-feminism and Tamara Drewe.' *College Literature*, 38:3 (2011), pp. 45–65

Leclerc, Yvan, 'Gemma Bovery, c'est elle', *Philosophie Magazine, Special BD*: 'La Vie a-t-elle du sens?', Philo Editions, 2013

Posy Simmonds, exh. cat., introduction by Liz Forgan, Guardian, 2009

'The Posy Simmonds Interview', conducted by Paul Gravett, *Comics Journal*, 286 (November 2007), pp. 26–67

Watts, Andrew, 'Cracks in a cartoon landscape: Fragmenting memory in Posy Simmonds' "Gemma Bovery"', *Essays in French Literature and Culture*, 48 (November 2011), pp. 45–65

1945 Posy born 9 August, near
Maidenhead, Berkshire

1948–1951 Attends Vicarage school,
Cookham Dean

1951–1955 Attends Herries School,
Cookham Dean

1956–1962 Attends Queen Anne's
School, Caversham

1962–1963 Studies Cours de
Civilisation Française at the
Sorbonne, Paris

1963–1964 Studies at the Heatherley
School of Fine Art, London

1964–1968 Studies at Central School of
Arts and Crafts, London; awarded
BA Art & Design

1966 First published work, dustjacket
illustration and typography for
The Grass Beneath the Wire, a
novel by John Pollock

1969 First book, *The Posy Simmonds
Bear Book,* published by Berkeley,
London

1969–1975 Daily 'Bear' cartoons in the
Sun; a selection is reprinted in
two paperbacks, 1974 and 1975

1969–present Freelance illustrator,
cartoonist and writer for
newspapers and magazines

1974 Marries Richard Hollis

1974 Exhibition at Mel Calman's
gallery, The Workshop, London

1976 Exhibition at Mel Calman's
Cartoon Gallery, London

1977 16 May, 'The Silent Three of St
Botolph's' weekly strip begins on
the *Guardian* Women's Page

1977–87 Weekly comic strips in the
Guardian

1979 *Mrs Weber's Diary* published, first
of five collections of reprinted
strips

1980 and 1981 Cartoonist of the Year in
British Press Awards

1981 *True Love* published, considered
by some to be the first modern
British graphic novel

1981 Exhibition at Museum of Modern
Art Oxford

1982–1983 Fifteen one-page comics in
the monthly *Harper's Magazine*,
New York

1985 Exhibition at Manor House
Museum & Art Gallery, Ilkley,
Yorkshire

1987 *Fred*, first children's book

1988 *Lulu and the Flying Babies*
children's book published

1988–1989 Two calendars of monthly
colour cartoons in the *Spectator*

1988–1990 Weekly, monthly or
occasional comic strips in the
Guardian

1991 *Tresoddit for Easter*, BBC TV
documentary

1992–93 Weekly comic strips in the
Guardian

1997 *Fred*, animated by Joanna Quinn
as *Famous Fred*; nominated for an
Oscar in 1998

1998 National Art Library Illustration
Award

1999 *Gemma Bovery* daily serial in the
Guardian; published as graphic
novel

1999 7 October–30 November, *Posy
Simmonds' Gemma Bovery*
exhibition at the British Cartoon
Centre, London

1999 and 2002 Strip Cartoonist of the
Year in Cartoon Art Trust Awards

2000–2001 11 November–7 January,
exhibition of work from 1984
onwards at the Barbican, London,
curated by Carol Brown

2001 *Gemma Bovery* wins Joint
First Prize for Best Book in the
Anglo-American School at Romics
Festival, Rome

2002 Awarded MBE for services to the
newspaper industry

2002 Illustrates *The Folio Book of
Humorous Verse*

2002 *Gemma Bovery* wins Haxtur
Award for Best Script at the
International Comics Convention
of the Principality of Asturias,
Spain

2002–2004 'Literary Life' weekly strips
in the *Guardian*

2003 *Literary Life* collection and
Lavender children's book
published

2004 *Baker Cat* children's book
published

2004 Elected a Fellow of the Royal
Society of Literature

2005 'Tamara Drewe' weekly serial
begins in the *Guardian*

2005 *Gemma Bovery* published by
Pantheon, New York, her first non-
children's book issued in the US

2006 Purchase by the Scott Trust
Foundation (Scott Trust Limited
owns Guardian Media Group) of
original artwork for the *Guardian*
(1977–2004)

2007 Revised version of *Tamara Drewe*
published as graphic novel

2007 Awarded the Pont Cup for drawing
The British Character

2009 *Tamara Drewe* nominated for
Eisner Award for Best US Edition
of International Material

2009 *Tamara Drewe* wins the Prix
Essentiel in the Palmarès Officiel
du Festival international de la
bande dessinée d'Angoulême,
France

2009 *Tamara Drewe* wins Grand Prix de
la Critique in France

2009 The *Guardian* exhibits Posy
Simmonds's original artworks
from its Archive

2010 Film adaptation of *Tamara Drewe*,
directed by Stephen Frears

2012 12 June–25 November, first
major retrospective exhibition at
the Belgian Comic Strip Center,
Brussels

2014 French film adaptation of *Gemma
Bovery*, directed by Anne Fontaine

2014 Admitted into the British Comic
Awards' Hall of Fame

2016 *Literary Life Revisited* published

2017 Chair of the Jury for the Palmarès
Officiel du Festival international
de la bande dessinée d'Angoulême,
France

2018 *Gemma Bovery* adapted into
a four-hour radio serial in ten
episodes on France Culture

2018 16 June–9 September, *Posy
Simmonds: Original Artwork and
Unseen Sketches* exhibition at
Mercer Art Gallery, Harrogate,
Yorkshire

2018 Nominated for the Hall of Fame,
Eisner Awards at San Diego
Comic-Con International, USA

2018 *Cassandra Darke* published
directly as a book

2019 First major retrospective
exhibitions in the UK at House of
Illustration, London and in France
at Pulp Festival, La Ferme du
Buisson, Paris

ACKNOWLEDGMENTS

First and foremost, I cannot thank Posy Simmonds enough for answering my many questions and allowing me to 'rummage through her drawers' for artworks and artefacts. Her husband, Richard Hollis, was also always helpful and provided numerous scans. I am also very grateful to the following: series editor Claudia Zeff; Julia MacKenzie, Amber Husain and all at Thames & Hudson for bringing this book to fruition; Olivia Ahmad and House of Illustration; Philippa Mole, Head of Archive at Guardian News & Media; Jane Sellars, Karen Southworth and the team at the Mercer Art Gallery, Harrogate; Annette Brook and Martha Stenhouse at the Royal Society of Literature; Dan Franklin at Jonathan Cape; Andre Gailani from Punch; Lucie Campos and Natacha Antolini at the

Institut Français, London; Joanna Quinn of *Famous Fred*; Judy Willcocks at Central Saint Martins; Jean-Claude de la Royère and Didier Giernaert from the Comics Art Museum, Brussels; Vincent Eches and Philippe Fourchon from PULP Festival, Paris; and for their invaluable information and insights, Rachael Ball, Martin Barker, Roger Malbert, Woodrow Phoenix, David Roach, Roger Sabin, Richard Sheaf and Russell Willis.

Finally, I would like to dedicate this book to the brilliant cartoonist Mel Calman (1931–1994), who was so supportive of Posy Simmonds through her career and helped me when I began my tenure in 1992 as Project Director of the Cartoon Art Trust, London.

CONTRIBUTORS

Paul Gravett is a widely published writer specializing in international comics. His books include *Graphic Novels: Stories to Change Your Life, Comics Art,* and *Mangasia: The Definitive Guide to Asian Comics.* He also curates exhibitions about comics, which have included retrospectives of the work of Tove Jansson, Charles Schulz and Posy Simmonds. www.paulgravett.com

Quentin Blake is one of Britain's most distinguished illustrators. For twenty years he taught at the Royal College of Art where he was head of the illustration department from 1978

to 1986. Blake received a knighthood in 2013 for his services to illustration and in 2014 was admitted to the Légion d'honneur in France.

Claudia Zeff is an art director who has commissioned illustration for book jackets, magazines and children's books over a number of years. She helped set up the House of Illustration with Quentin Blake where she is now Deputy Chair. Since 2011 she has worked as Creative Consultant to Quentin Blake.

INDEX